WILD ACADIA

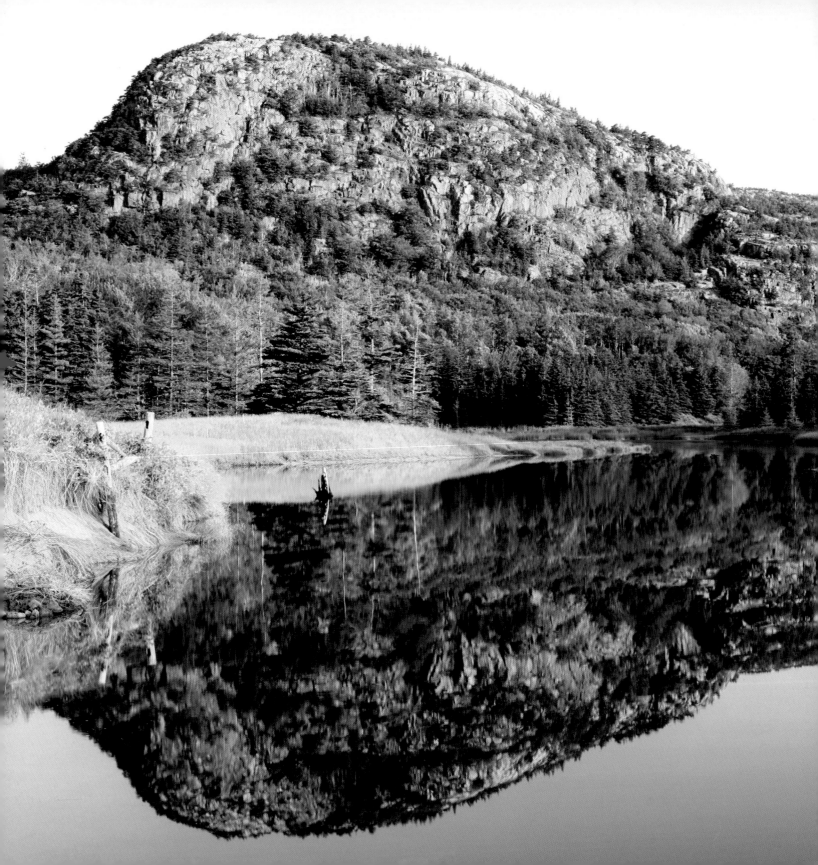

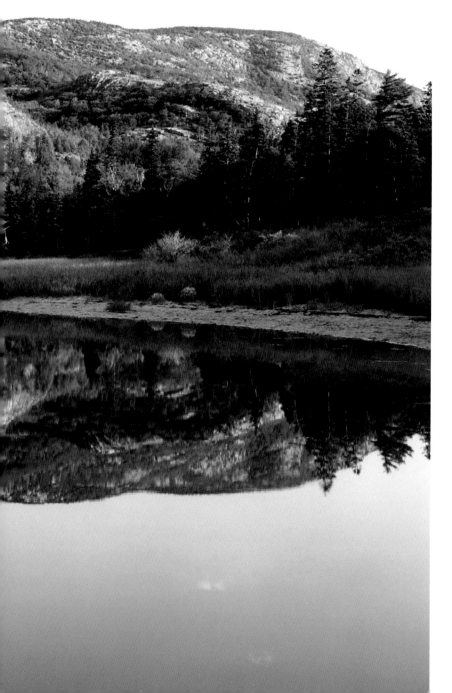

WILD ACADIA

A Photographic Journey to New England's Oldest National Park

Images by Jerry and Marcy Monkman

Text by Jerry Monkman

University Press of New England

Hanover and London

Published by University Press of New England,

One Court Street, Lebanon, NH 03766

www.upne.com

© 2007 by University Press of New England

Printed in China

5 4 3 2 1

LIBRARY OF CONGRESS CATALOGING-IN-PUBLICATION DATA

Monkman, Jerry.

 Wild Acadia : a photographic journey to New England's oldest national park / Images by Jerry and
Marcy Monkman ; Text by Jerry Monkman. — 1st ed.

 p. cm.

 ISBN-13: 978 – 1 – 58465 – 524 – 4 (cloth : alk. paper)

 ISBN-10: 1 – 58465 – 524 – 0 (cloth : alk. paper)

 1. Acadia National Park (Me.)–Pictorial works. I. Monkman, Marcy. II. Title.

 F27.M9M55 2007

 974.1'45–dc22 2006035256

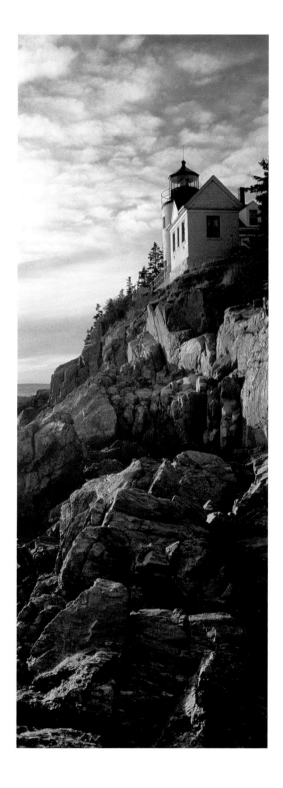

CONTENTS

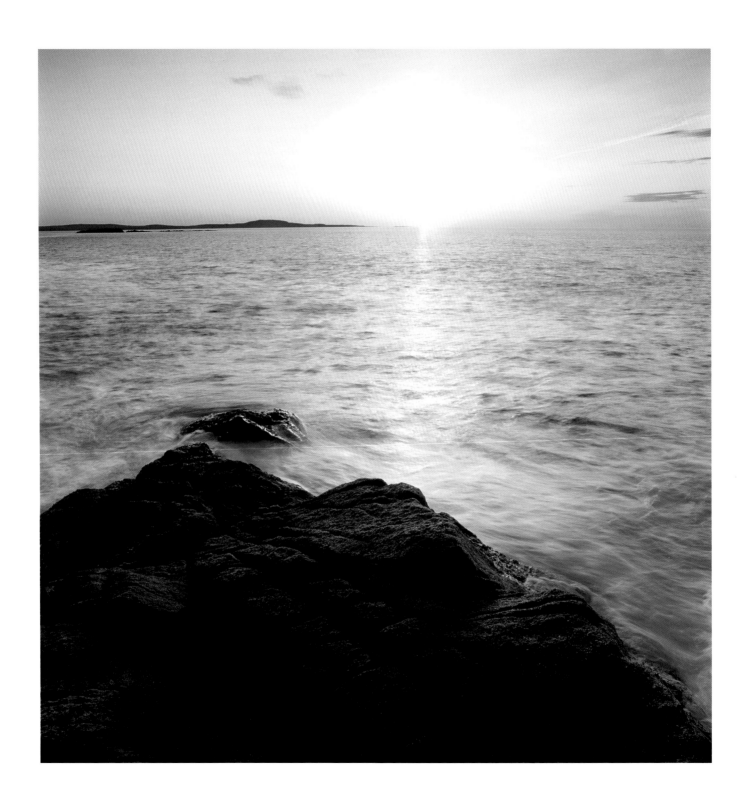

ACKNOWLEDGMENTS

Marcy and I would like to send a big thank you to all those who helped make *Wild Acadia* possible. At the top of the list are the many talented people at the University Press of New England. In particular, Ellen Wicklum, our editor, and Mike Burton, UPNE director, both showed great patience and knowledge of their craft in turning our words and pictures into a book that we are proud to add to the deep collection of material about Acadia that already exists. We also must thank John Landrigan, who signed us up for this project and who helped us develop its concept when editing our previous book, *White Mountain Wilderness*.

Several people at the National Park Service proved invaluable in our research: Wanda Moran, Brooke Childrey, Marc Neidig, Bruce Connery, and John McDade. We also must thank Ken Olson at Friends of Acadia, and Brian Reilly and David MacDonald at the Maine Coast Heritage Trust. All three were very helpful in helping us understand the conservation issues facing Acadia and the surrounding communities.

Finally, we must give a warm thanks to our friends and family who have always wholeheartedly supported us in our not always rational endeavors as "eco-photographers."

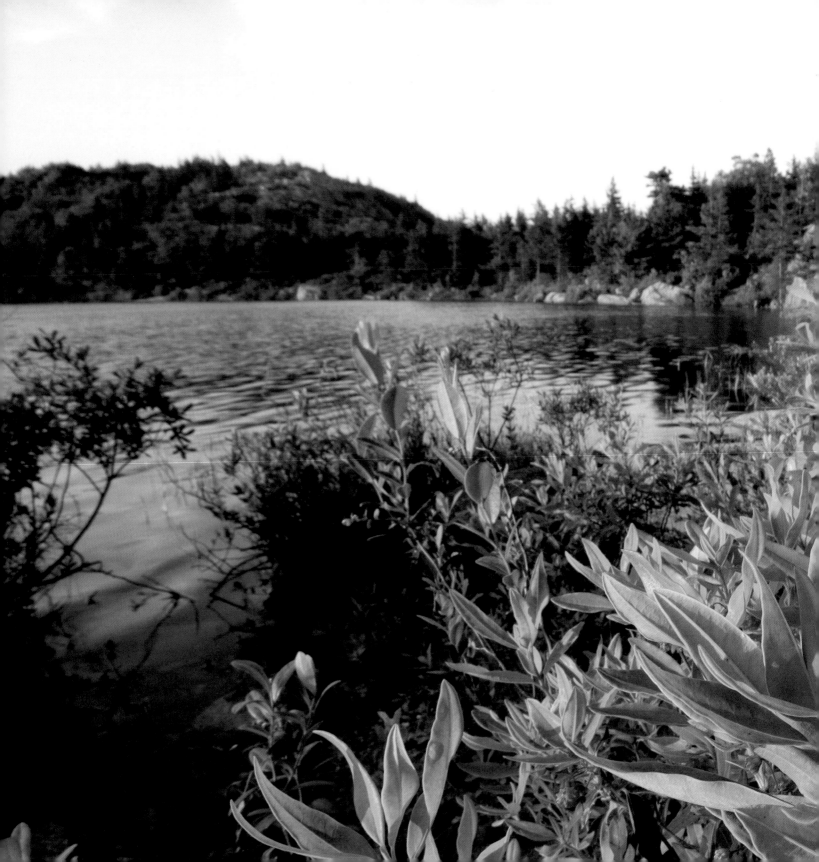

Wild Acadia

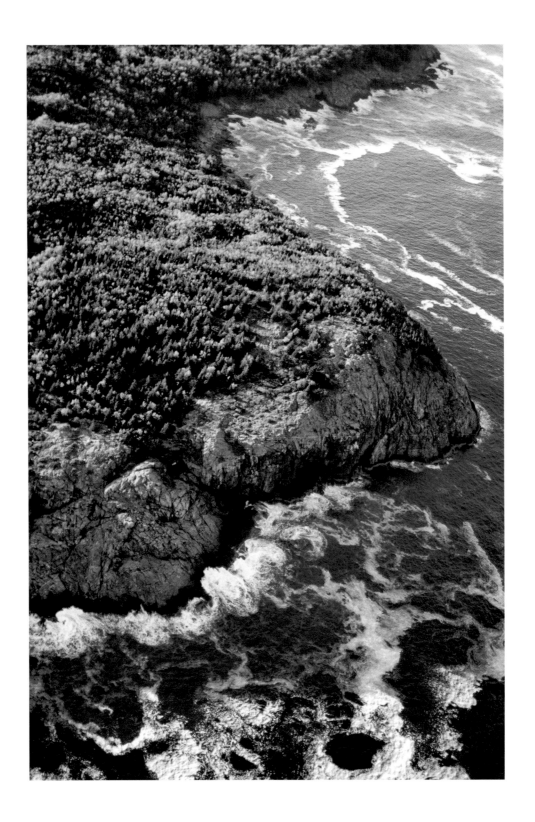

INTRODUCTION

Maine's acadia national park is like a microcosm of New England's wild places, with dramatic coastal headlands, rich forested valleys, spruce-covered islands, and windswept, rocky mountaintops. Bald eagles and peregrine falcons patrol the skies while seals, whales, and porpoises swim offshore. In the park's forests and wetlands, otters fish in ponds created by beavers, as bobcats and coyotes den in the hardwood forests and hunt in nearby meadows. Most visitors to national parks hope to see some wildlife, but in Acadia it is the scenery that grabs you, makes you want to stay longer, and has you planning your next visit before you have even finished your first.

Marcy and I have visited Acadia every year since we first ventured into the park in 1989, when we were instantly smitten with Acadia's combination of mountain landscapes and ocean breezes. We were two recent college graduates, having just transplanted ourselves from Illinois to New England, and we reveled in the fact that we could easily drive to a place where we could hike rugged granite domes in the morning and then spend the afternoon lazing on a sandy beach watching loons and cormorants diving for fish in the sparkling azure waters of the Atlantic. We so fell in love with this place that when our daughter was born twelve years later, we named her Acadia.

Acadia (the park, not our daughter) is about 48,000 acres in size. Most of that total is located on Mount Desert Island, the third-largest island in the continental United States. To the east of Mount Desert Island, 2,100 acres of the park are located on the Schoodic Peninsula, the only part of the park on the mainland. The remainder of Acadia is found on several islands stretching to the south and west from Mount Desert for twenty-five miles to Isle au Haut in what is known as the Acadian archipelago. Sixteenth-century maps of the region named it La Cadie, either for its resemblance to the Arcadia region of Greece or as a derivation of the Native American word for the area. Both Isle au Haut and Mount Desert (L'Isles des Monts-Desert in French) were named in 1604 by French explorer Samuel de Champlain, who is generally credited with being the first

European to come ashore on these islands. Both names, meaning "High Island" and "Island of the Desert Mountains," still describe these islands well.

Though the Acadia region has now been settled for centuries and the park is visited and loved by millions every year, it is still a place that retains much of its wild beauty. *Wild Acadia* is a celebration of that beauty and is the result of more than a decade of visits ranging from a weekend to three weeks in length. Some of the photos in this book were made after repeated trips to favorite places in search of the perfect lighting conditions for the scene. Other photos just happened spontaneously when on a hike or paddle or walk, solo, as a pair, or with our kids. All the images in this book strive to portray the wild beauty that inspires us to come back to this special part of the world year after year. Marcy and I hope that our photos will inspire you to regularly explore the beauty of Acadia, whether it seems new and exotic or comfortable and familiar, and that these explorations encourage you to participate in the efforts to keep Acadia wild for generations to come.

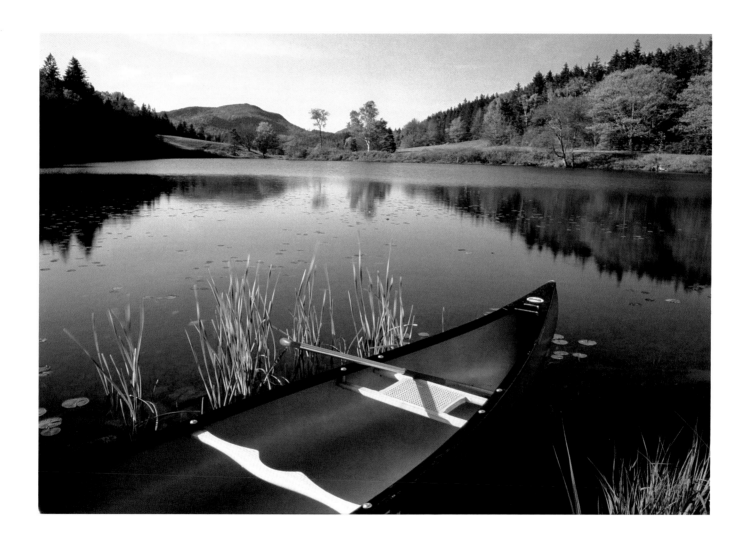

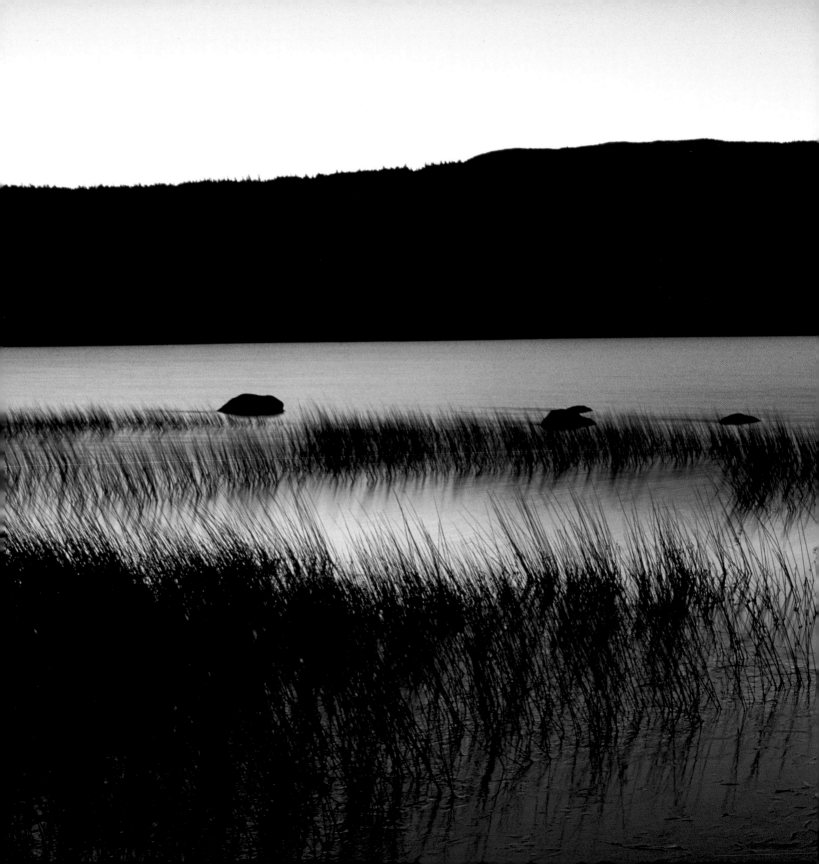

Creation and
Preservation

WHILE STANDING ON THE BACK LAWN of the Jordan Pond House on Mount Desert Island in Maine's Acadia National Park, visitors are treated to one of the more graceful, picture-postcard-perfect views in America. The peaceful, sky blue waters of Jordan Pond stretch from the bottom of the lawn for more than a mile to the rounded, twin granite peaks known as the Bubbles, which rise from the pond's northern shore like a pair of six-hundred-foot-high, well, bubbles. To the west, the pink granite cliffs of Penobscot Mountain rise steeply from the shoreline, playing the wild dramatic foil to the gentle calm of the lake. Whenever I see this view I am thankful that this scene has survived thousands of years of human visitors, but at the same time this view hardly seems the result of natural processes. It is just that perfect.

Of course, the beauty of Jordan Pond and the rest of Acadia National Park is a result of natural geologic events, but it wouldn't exist in an undeveloped state today except for an unprecedented effort by an early twentieth-century summer resident, George Dorr, to preserve the places that now make up the park. The geology took hundreds of millions of years. In contrast, Dorr's preservation efforts took less than half a century, but in many ways they are still under way today.

That preservation effort has made it possible to enjoy a walk around a quiet, development-free Jordan Pond, enjoying the views, the wildflowers, and the loons in the process. I have often walked halfway around the pond and then up the trail to the summit of the South Bubble, where I scan the skies for peregrine falcons as my heart rate slows with the sight of the blue waters of Jordan Pond and the ocean beyond. The view is so freeing, so wide open, that it is hard to imagine that the rock that is the mountain is more than 300 million years old or that at times in the distant past it lay beneath thousands of feet of ice or rock, but that is exactly the case.

FIRE AND ICE

The bubbles and the other rounded domes in Acadia, including Cadillac Mountain (the park's highest peak), were formed during an event known as the Acadian Orogeny, which began approximately 360 million years ago. At that time, a piece of Earth's crust called Avalonia

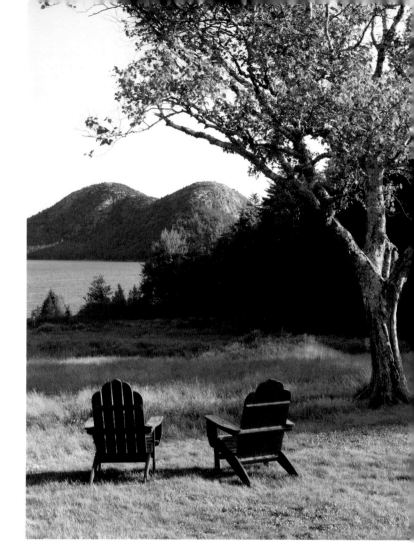

The view of Jordan Pond and the Bubbles from the lawn of
the Jordan Pond Tea House has been captivating visitors since
the late 1800s.

plunged under the surface as it was crushed between northern Europe and North America, a
process known as subduction. Eventually, this crustal material was buried deep enough that it
melted into magma and then slowly cooled underground, forming the granites that make up
most of the mountains of Acadia.

This new rock remained underground for millions of years, but it was slowly lifted as north-
ern Europe continued to crash into New England. When the continents eventually separated
again around 200 million years ago, the granite domes of Acadia were no longer deep inside the
Earth, but they still had not seen the light of day as they lay inside massive mountains, overlain

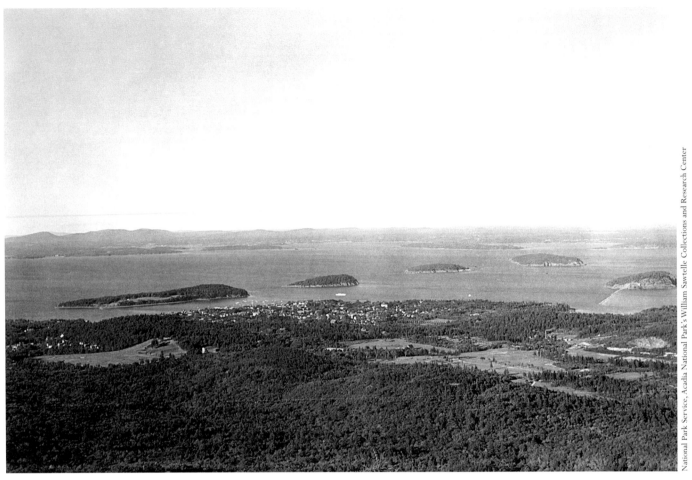

National Park Service, Acadia National Park's William Sawtelle Collections and Research Center

Bar Harbor, Bar Island, and the Porcupine Islands as seen from the summit of Cadillac Mountain in 1932 and 2005.

with thousands of feet of metamorphic rock, primarily schist. To stand on the granite of the Bubbles would have involved a great deal of drilling, blasting, and earthmoving first.

Millions of years of erosion by wind and water slowly blew and washed away the massive prehistorical mountains of Acadia until about two or three million years ago, when the process was accelerated by a series of as many as thirty ice ages. During these periods of glaciation, which could last eighty thousand years each, the area that makes up the Maine coast was buried beneath thousands of feet of ice, which flowed from north to south, grinding and chipping and pushing away all the rock that wasn't hard enough to fight back.

The work of glaciers in Acadia is easy to see and imagine after just a few trips to the park's summits. On the South Bubble, there are grooves in the granite, carved by rocks stuck in the bot-

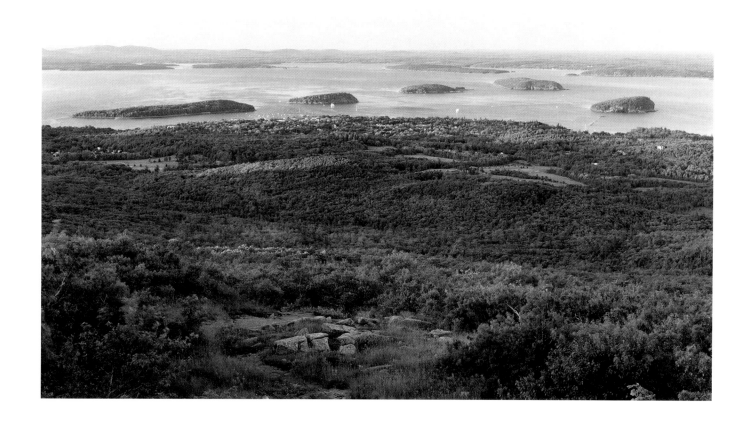

tom of the ice sheet, and the valley that holds Jordan Pond is a classic glacially carved U-shaped valley, with the pond forming the bottom of the U and the cliffs of Penobscot Mountain on the west and the Bubbles and Pemetic Mountain on the east forming the sides. Similar examples abound throughout the park.

HUMANS DISCOVER THE BOUNTY OF ACADIA

One recent spring day, instead of hiking up the South Bubble, I turned right off the Jordan Pond Loop Trail onto the Jordan Pond Carry Trail, an old Native American portage trail that connects the pond to the south shore of Eagle Lake. Native Americans probably first wandered

the lands that make up Acadia soon after the last glaciers retreated 12,000 to 14,000 years ago, though the earliest archaeological discoveries in the park date back about 6,000 years. I have no proof that this path is 12,000 years old, but if it was created by the island's first human inhabitants, it most likely would have traversed a treeless landscape full of tundra plants and populated by woolly mammoths and herds of caribou. By 6,000 years ago, the climate would have warmed sufficiently so that spruce and fir trees would have replaced the tundra, creating the dark boreal forests that are still common in some parts of the park and in much of northern Maine.

Around 3,000 years ago, portaging a canoe along this trail would have been much like the hike is today, a relatively easy walk through mostly northern hardwood forests on the drier land with lush groves of hemlocks growing along the stream courses. On the early spring day of my hike, it is sunny in the leafless hardwood forests, sleek gray tree trunks reaching upward against a backdrop of mountain ridges, which won't be visible in a few weeks as the trees leaf out. In the hemlocks it is darker, of course, and it feels colder, and this feeling is just as prominent in the grove of tall red spruce trees that make up the last hundred yards of forest before the trail ends at Eagle Lake.

As I step out of the trees and look out over the lake, a smile falls across my face, though I'm not sure why. Is it from a sense of accomplishment? Is it relief at being out of the woods and at the end of the trail? Or is it a feeling of excitement and wonder at the dramatic scene in front of me? Did the Wabanaki natives who last used this trail before European colonization feel that same sense of joy when they dropped their birch bark canoes on the shore of the lake? I won't assume to know the answer to that question, but I do know that I always get this feeling in Acadia when I step out of the woods, whether it is onto the shore of a pond, onto a cobble beach facing the open Atlantic, or onto the treeless ledges of a rocky peak.

The Wabanaki who lived on this part of the Maine coast during the time of first European contact as well as their ancestors who lived here for thousands of years before that are known to have lived in seasonal camps, moving between the coast and inland rivers and forests. They harvested shellfish and sea mammals along the coast, salmon on the rivers, and moose in the forests. Most archaeological evidence of pre-Columbian Native American life in Acadia is found in shell

middens on the coast—basically large garbage heaps that consist primarily of mussel and clam shells but also contain stone and bone tools, pottery shards, and other artifacts of daily life.

There is still some debate as to which time of year the Native Americans lived on the coast, but recent evidence suggests that they spent summers on rivers in the interior, taking advantage of bountiful runs of Atlantic salmon, and then avoided the harshest weather of Maine winters by living in milder coastal areas, subsisting on fish, porpoises, seals, and shellfish. The reality of the Wabanaki lifestyle was probably a little more complicated than this cut-and-dry description, for written accounts from early European explorers describe Native camps on the coast during the summer months. It is also known that at the time of first contact, some of Maine's Wabanaki lived in more permanent villages that were organized into a confederacy led by Chief Bessabez, who lived in a village on the Penobscot River.

By 1600, it is estimated that approximately thirty-two thousand Wabanaki ("People of the Dawn") lived in Maine as part of four tribes, the Passamaquoddy, Micmac, Maliseet, and Penobscot. However, like most tribes in the Northeast, their population was decimated after first contact as European diseases wiped out an estimated 75 percent of the population by 1620. The weakened tribes then suffered centuries of persecution and outright attack primarily at the hands of British settlers and then the early American and state governments, losing access to most of the land they had historically occupied and used to sustain their culture. However, all four tribes still live in Maine today, and they have gained back a small amount of their land through favorable court rulings in the latter half of the twentieth century. (To learn more about Native Americans while in Acadia, visit the excellent Abbe Museum in Bar Harbor.)

FROM NO-MAN'S-LAND TO PLAYGROUND OF THE RICH AND FAMOUS

From the ledges on the east side of Acadia Mountain it is a steep, six-hundred-foot drop to the deep waters of Somes Sound. On the opposite shore, this east face of the mountain is mirrored by the equally steep west face of Norumbega Mountain. Like the valley that contains Jordan Pond, Somes Sound runs north-south, carved by glaciers during the last ice age, and most of

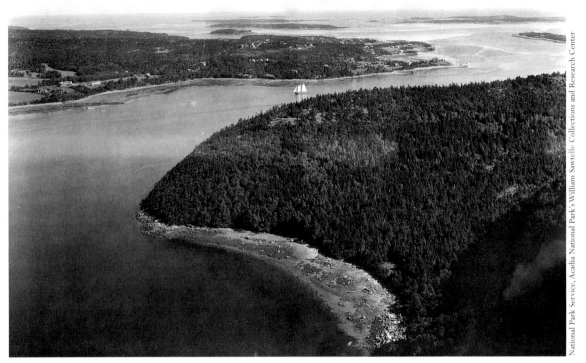

Somes Sound with its sheltered coves and harbors is where settlement on Mount Desert Island began in earnest just prior to the Revolutionary War.

the valley is now drowned by the waters of the Atlantic forming what is often called the only fjord in the eastern United States. The fjord reaches deeply into Mount Desert Island, nearly cutting it in two, and contains several deep coves and harbors, making it prime real estate for both early settlers and modern yachtsmen.

One of the richest Native American archaeological sites in Acadia is on Fernald Point at the entrance to Somes Sound, not far from Acadia Mountain. This is also possibly the site of the first European settlement on the island, dated at 1613, when French Jesuits set up a village only to have it quickly destroyed by an English warship dispatched from the Jamestown colony. Mount Desert Island and the rest of the eastern Maine coast remained a flash point between French and British interests for the next 150 years, and the lands that would become Acadia remained relatively free of colonization until after the British defeated the French on the Plains of Abraham in Quebec to end the French and Indian Wars in 1759. The British victory paved the way for English settlement of eastern Maine and Atlantic Canada.

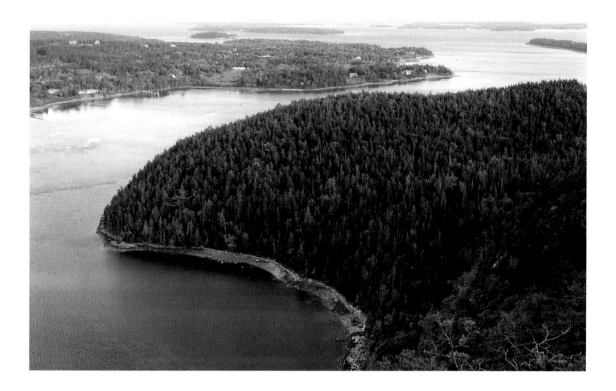

When European settlement did take hold in the region in the 1760s, it started in and around Somes Sound. The first settlers to be noted in the historical records were Abraham Somes and John Richardson, who built cabins in what is now Somesville at the head of the sound. Within fifty years, Mount Desert Island was home to about two thousand residents, primarily fishermen and farmers. Near the mouth of the sound, Southwest Harbor and the Cranberry Islands grew into important communities that thrived throughout the nineteenth century on commercial fishing and a fleet of as many as eighty-five merchant ships that sailed up and down the East Coast, to Europe, and to the West Indies.

This pattern of economic growth was common in harbors all along the Maine coast during this period, but the unique beauty of Mount Desert Island steered it toward a future separate from that of its neighbors, a future of popularity, overcrowding, and then preservation. Like other mountainous regions of New England, in the 1840s Mount Desert Island was discovered and made famous by Thomas Cole, Frederic Church, and other painters of the Hudson River School of American landscape painting. Their romantic works featuring such Acadia icons as Eagle Lake, the Beehive, and the Porcupine Islands were inspiration to many who made the long jour-

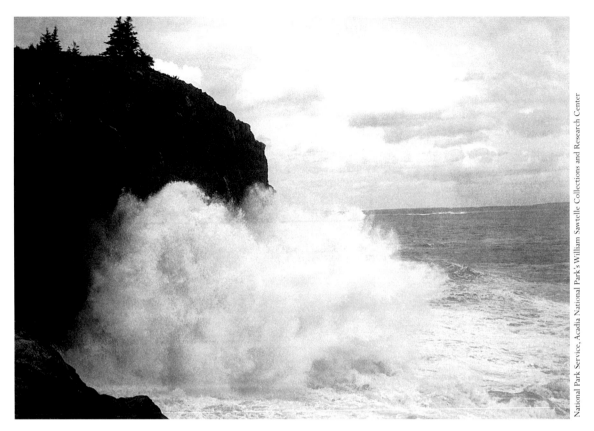

National Park Service, Acadia National Park's William Sawtelle Collections and Research Center

At 145 feet tall, Great Head is the highest headland on Mount Desert Island.

that perfectly reflects the pink cliffs of an odd little peak called the Beehive. If it wasn't for the cliff-framed view seaward from the beach, this view of the Beehive would be the most stunning of the hike. Then again, the competition is steep. About three-quarters of a mile from the beach, the summit of Great Head sits atop a 145-foot cliff, where there are eye-popping, 180-degree views of ocean, cliffs, and islands.

On the summit of Great Head are stone remnants of a teahouse built here during the heyday of Mount Desert Island in the late nineteenth and early twentieth centuries, when the island was the summer home to the richest families in America – Kennedys, Rockefellers, Morgans, Carnegies, Vanderbilts, to name just a few. The entire route of the hike to Great Head, including Sand Beach, was once owned by the Morgan family. Much of the island's most scenic properties were purchased by America's elite to build summer "cottages" with as many as eighty rooms and staffs of more than a dozen servants. At the height of the cottage era, there were more than ninety of these opulent estates. These summer residents brought huge amounts of capital to the island,

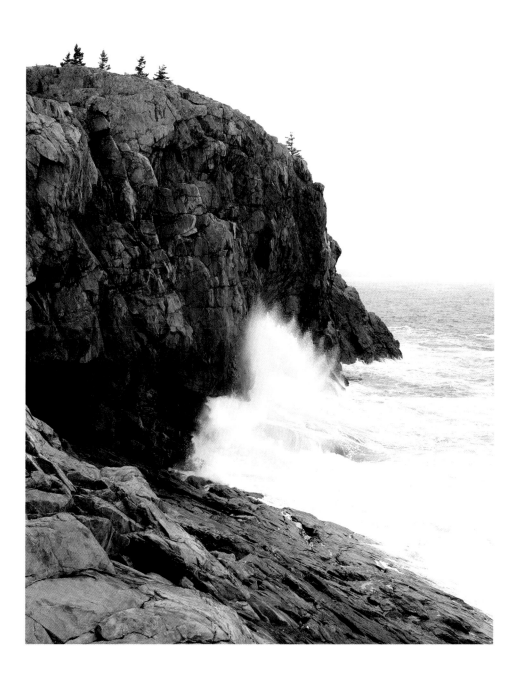

which financed numerous public works and cultural projects as well as the formation of village improvement societies that took to building close to two hundred miles of hiking trails in what would eventually become the park.

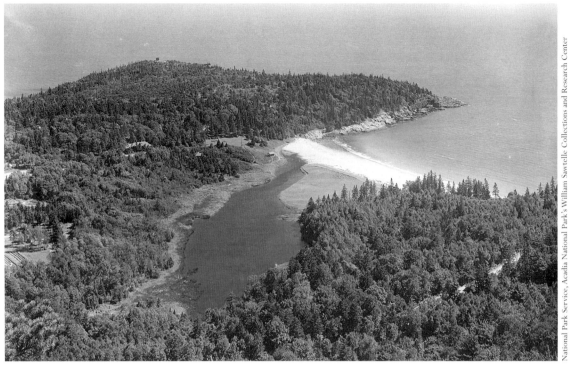

The historical photo is of Sand Beach and Great Head, which were once owned by J. P. Morgan, who gave the property to his daughter, Louisa Satterlee. In the historical photo it is possible to see the round teahouse on Great Head and the boathouse on the creek adjacent to Sand Beach. The Satterlee Estate was destroyed by the 1947 fire and eventually became part of the park.

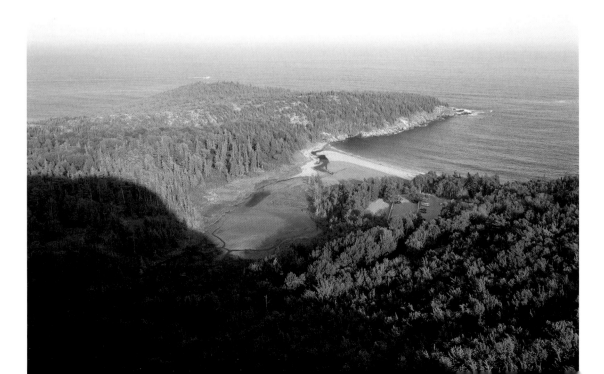

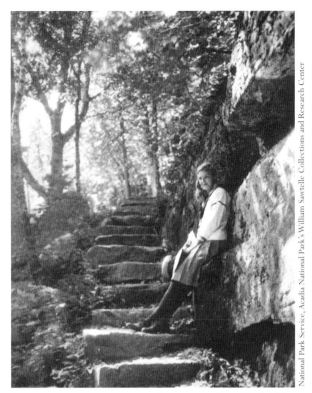

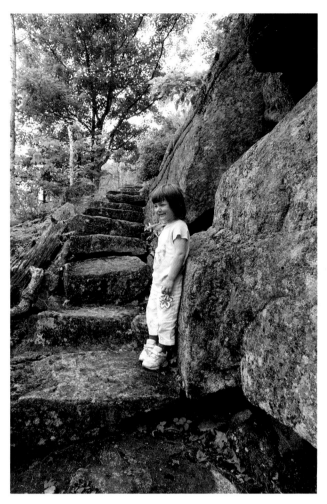

A young woman stands on granite steps on Kurt Diedrich's Climb on Dorr Mountain in 1920. A young girl re-creates the pose in 2005. Many trails like this one were constructed by village improvement societies in the late nineteenth and early twentieth centuries. They were often created as memorial paths, financed by donors wishing to name the path after a friend or loved one, in this case Kurt Diedrich.

THE FIRST NATIONAL PARK IN THE EAST

From sand beach you can make use of some of these historic trails to climb up and over the Beehive and then along a ridge to the summit of Champlain Mountain. From Champlain Mountain you can then walk down and around the summit of Huguenot Head, cross Maine Route 3, and walk past a pond called the Tarn to Sieur de Monts Springs, both of which are tucked beneath the steep and imposing east face of Dorr Mountain, named after George Dorr, the man considered to be the father of Acadia National Park.

At the turn of the twentieth century, Dorr was part of the island's elite, summering at his family's estate on Cromwell Harbor near Bar Harbor. In August 1901, he received a letter from

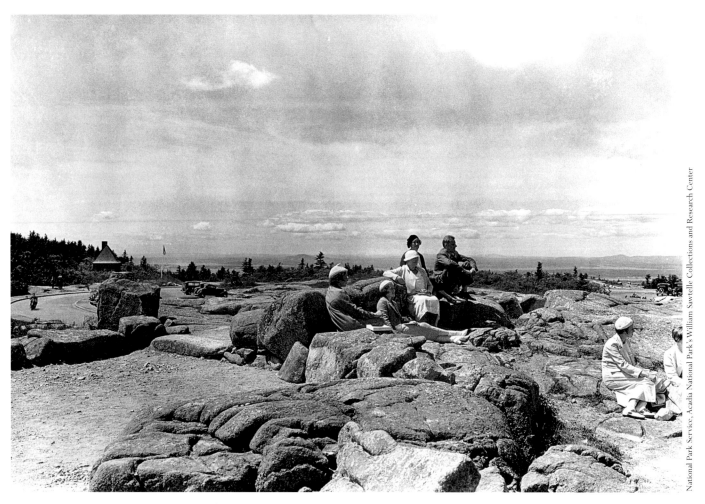

A popular spot with summer visitors ever since a cog railroad was built to the summit in 1882 (since dismantled), Cadillac Mountain is the highest coastal mountain in the eastern United States. The photo from 2005 shows more

Charles Elliot, a summer resident in Seal Harbor and president of Harvard University, asking him to attend a meeting that would result in the organization of the Hancock County Trustees of Reservations. Elliot was concerned that the recent invention of the portable sawmill would cause a rapid and unsustainable harvesting of the island's timber, which would in turn lead to erosion of the mountains' thin soil, leaving much of the island permanently devoid of trees. Successfully organized, the Trustees received two small symbolic plots of land in 1903 and then lay dormant for the next half decade.

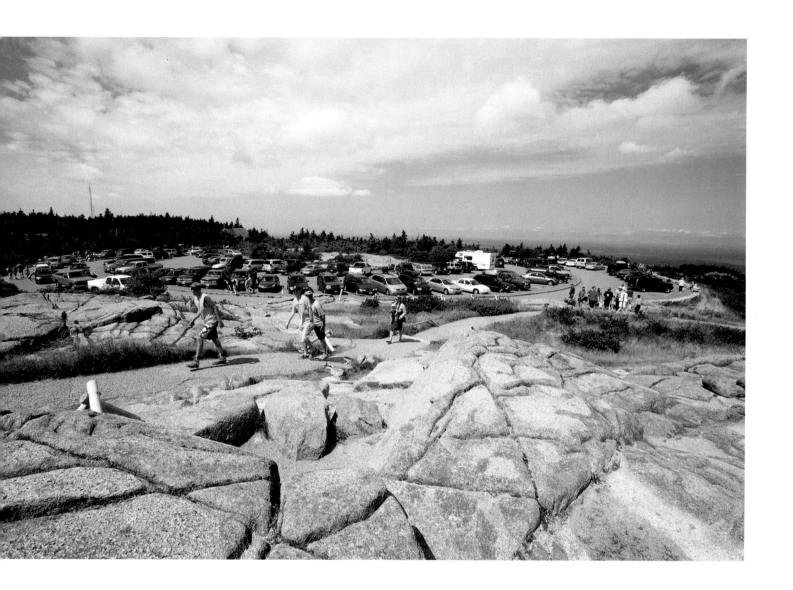

In September 1908, the Trustees received their first significant gift, a tract of land that included the Beehive and the Bowl, a small tarn on the north side of the mountain. Dorr considered this land to be "a gift singularly appropriate to the Trustees purpose, beautiful, unique, and wild," and this success was the inspiration he needed to devote much of the remainder of his life to creating what would be become the national park. During the next five years, Dorr tirelessly sought ways to acquire some of the most scenic and important lands on the island, spending from his own fortune and persuading others to contribute (primarily his Bar Harbor neighbor John S.

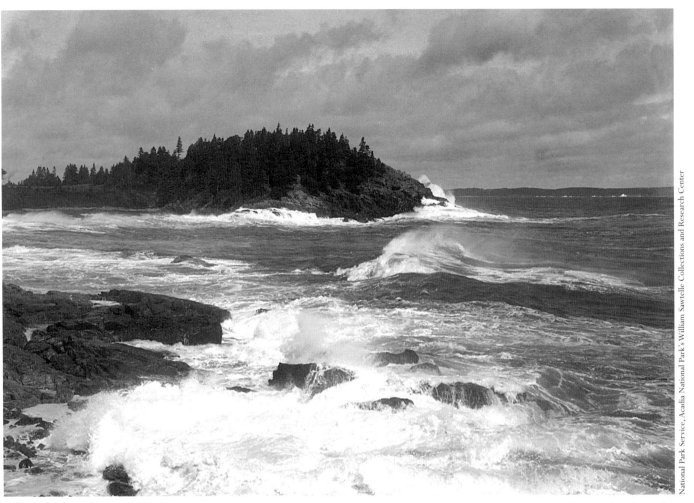

This scene looking toward Schooner Head from the rocks above Anemone Cave shows how development has changed the look of this stretch of coastline between 1932 and 2005.

Kennedy). By 1913, Dorr had grown the holdings of the Trustees to approximately six thousand acres, which included the summit of Cadillac Mountain, Champlain Mountain and Huguenot Head, Eagle Lake, the mountains around Jordan Pond including the Bubbles, Sieur de Monts Spring, and Otter Creek Gorge.

Dorr then decided to seek federal protection of these lands in the hope that they would become a national park. In 1913, there were no national parks east of the Mississippi, there was no law allowing a national park to be created from private lands, and there was no National Park Service (the U.S. Cavalry still was in charge of patrolling the most famous of the parks, Yellow-

stone.) Dorr spent more than two years traveling between Bar Harbor, Boston, and Washington, D.C., meeting with several cabinet members, President Wilson, and even the first lady, showing that he had some deft political skills and connections. In August 1916, President Wilson signed an executive order accepting a gift of lands from the Trustees and authorizing the creation of Sieur de Monts National Monument.

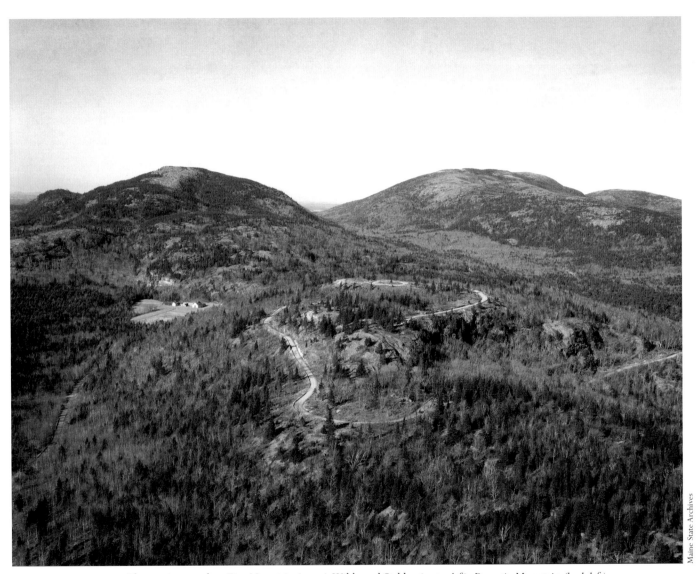

The carriage road up Day Mountain *(center)*, Wildwood Stables *(center left)*, Pemetic Mountain *(back left)*, and Cadillac Mountain *(back right)*.

In 1919, Congress authorized changing the status from a monument to a park, and Lafayette National Park was born (the name was changed to Acadia in 1929). Dorr agreed to become the park's first superintendent, receiving a monthly salary of one dollar. He continued to work selflessly on the park's behalf. In the 1920s and 1930s he oversaw expansion of the park to include such iconic parcels as Otter Cliffs, Ocean Drive, and the Schoodic Peninsula. During this period

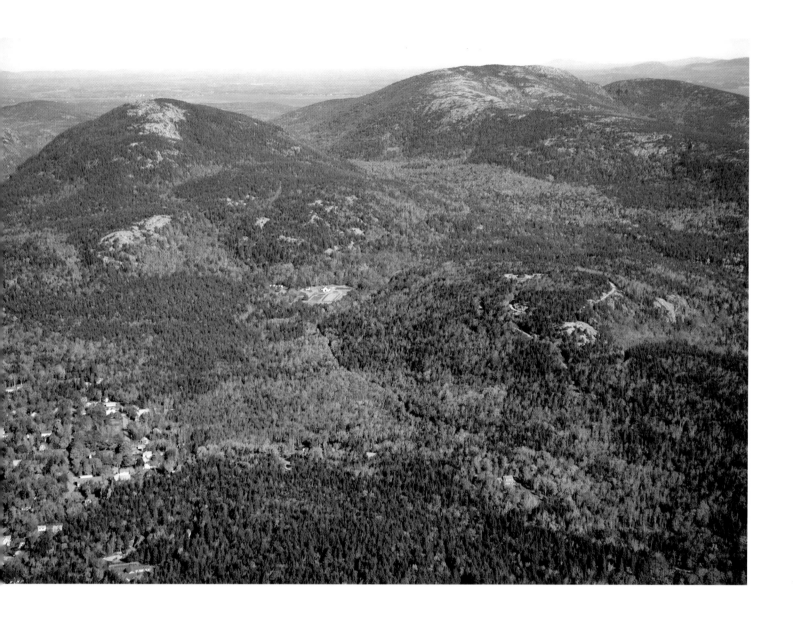

he benefited from great support from John D. Rockefeller, Jr., whose family owned a summer residence in Seal Harbor. Rockefeller used funds from his considerable fortune to purchase lands that would be added to the park as well as to build the Park Loop Road and fifty-plus miles of carriage roads in order to give people access to the park's backcountry without the intrusion of automobiles, which were first allowed on the island in 1915. Rockefeller used designs and mate-

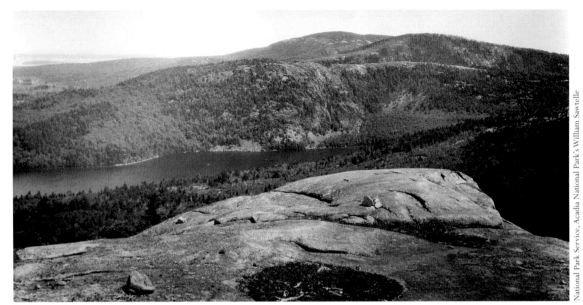

National Park Service, Acadia National Park's William Sawtelle Collections and Research Center

The view west from Acadia Mountain to Beech and Western mountains on the western side of Mount Desert Island in the 1920s. The view is very similar today. One difference is the fire tower that now stands atop Beech Mountain, constructed after a forest fire in 1947 burned 17,000 acres on the eastern half of the island.

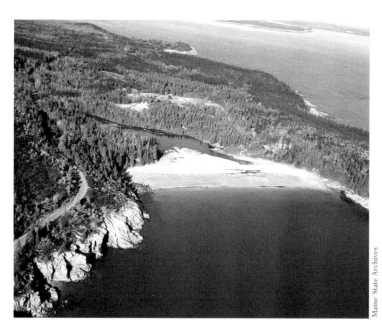

The Sand Beach area from the air. The historical photo was taken shortly after the 1947 fire—about half of the trees (the darker areas in the photo) are standing and charred spruce. The recent photo, taken in October 2005, shows the rebirth of the forest, the burned area coming back as hardwoods such as paper birch and sugar maple.

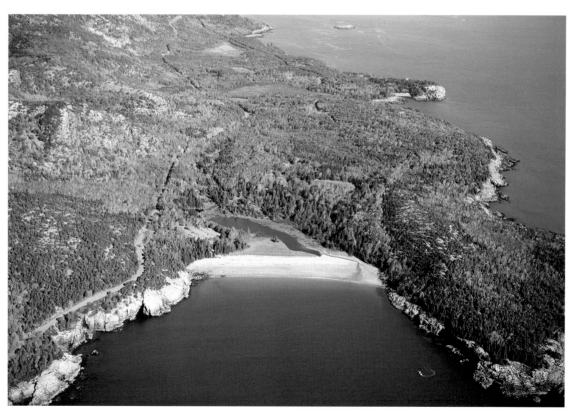

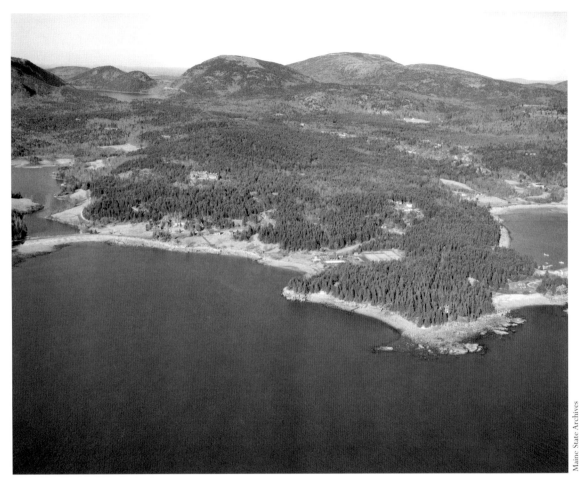

The foreground of this photo shows (*right to left*) Seal Harbor, Bracy Cove, and Little Long Pond. In the distance are (*right to left*) Dorr and Cadillac mountains, Pemetic Mountain, the Bubbles and Jordan Pond, and the eastern side of Penobscot Mountain. Taken soon after the 1947 fire, the original photo shows that the fire missed most of this part of the island.

rials that ensured the carriage roads were as beautiful as the park's natural features, and they are now one of the most popular features of Acadia.

When George Dorr died in 1944, he had completed one of the most successful conservation efforts in New England history, perhaps rivaled only by Percival Baxter's creation of Baxter State Park in Maine's north woods. Acadia National Park was well established and on its way to becoming one of the country's most popular national parks. The park is now consistently one of the top ten visited parks in the country, seeing between two and three million visitors each year. The park is now over forty-eight thousand acres in size and includes several thousand acres on the Schoodic

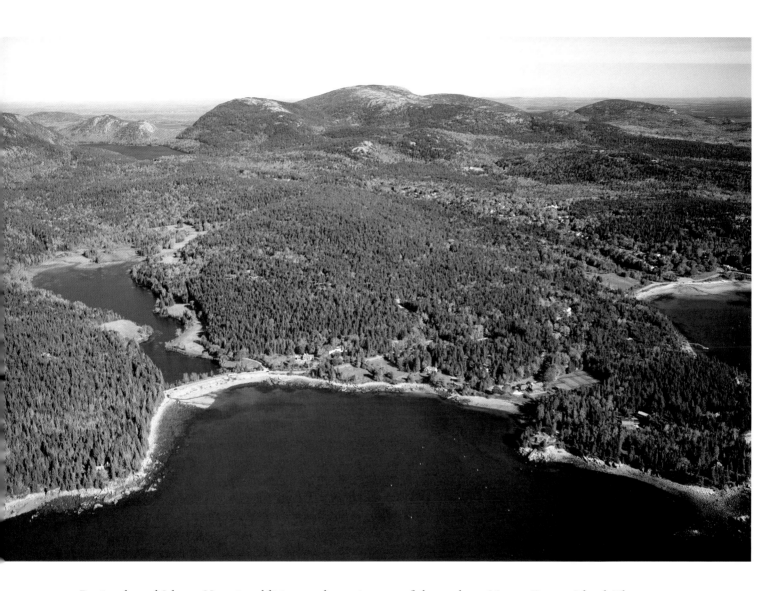

Peninsula and Isle au Haut in addition to the main part of the park on Mount Desert Island. The conservation efforts started by George Dorr and his colleagues continue to this day, with two major organizations working to protect the park and the environment surrounding it—Friends of Acadia and the Maine Coast Heritage Trust. In the twenty-first century, the park is a national treasure, but it is still threatened with overuse and by degradation of the surrounding environment. These organizations work with the Park Service, local communities, and nearby private landowners to ensure that the Acadia experience remains as wild and pristine as possible.

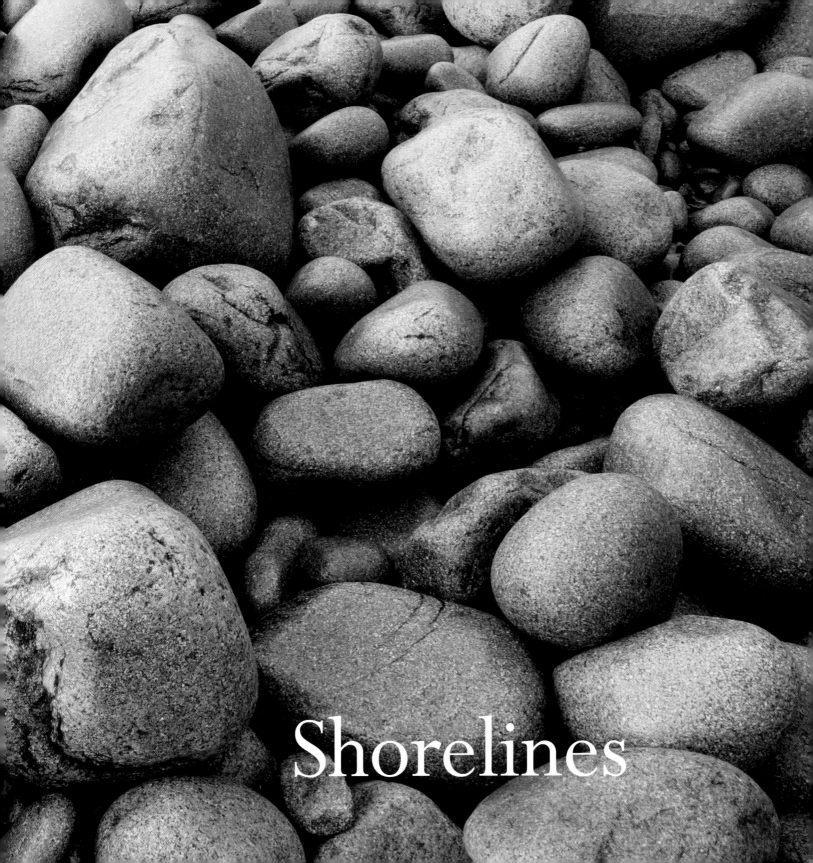

Shorelines

PINK GRANITE COBBLES. Sand composed of bits of clamshells and sea urchins. Smooth and slippery, dark basalt ledges. Despite a preponderance of spruce and rock, the shorelines of Acadia are surprisingly diverse, and it is difficult to choose one feature as an initial description of Acadia's shorelines. However, it was easy to decide to start the "nonhistorical" part of this book with the park's coastal edges. Whether you first arrive in Acadia by boat, car, bike, or even plane, it is the shoreline that first greets, tempts, and soothes you as you wash in like the tide, suddenly compelled to go barefoot and search the tide pools for sea stars, the bays for porpoises, and the skies for eagles.

In summer, high tide in terms of visitation, Acadia's shores are full of visitors fresh from the T-shirt shops of Bar Harbor, digital cameras around their necks and flip-flops on their feet. Despite this description, this is not the Jersey Shore. There are no boardwalks or arcades, and after the sun goes down, even the park's hot spots are very quiet. And, unlike most of the coastal playgrounds of the eastern United States, Acadia is not defined by sandy beaches (Sand Beach notwithstanding) but by miles of dramatic, rocky coastlines, its cobble beaches alternating with tall granite cliffs and ledges that bear the brunt of towering swells crashing in from the open Atlantic.

The drama of Acadia's shorelines served as inspiration for Dorr and friends to create what is now the national park, and Acadia's landscape is now well photographed and recognized far beyond Maine and the rest of New England. And that recognition brings between two and three million visitors every year, primarily in the summer months. That is a lot of traffic for a park smaller than fifty thousand acres, but Acadia's fame, combined with the fact that the shorelines of the park represent approximately 25 percent of all the publicly available shoreline in the state of Maine, make it easy to understand why the tour buses and minivans aim for Mount Desert Island. Of course, this means that the cobblestones of Little Hunters Beach and Monument Cove, the sticky grains of Sand Beach, and the ledges of Great Head are well traveled, annoyingly so on a warm sunny day in the summer. While the land in the park is protected from development, it is still threatened by these throngs of people who may well be "loving the park to death," and the Park Service is constantly working at mitigating the impact of these millions of visitors. Besides

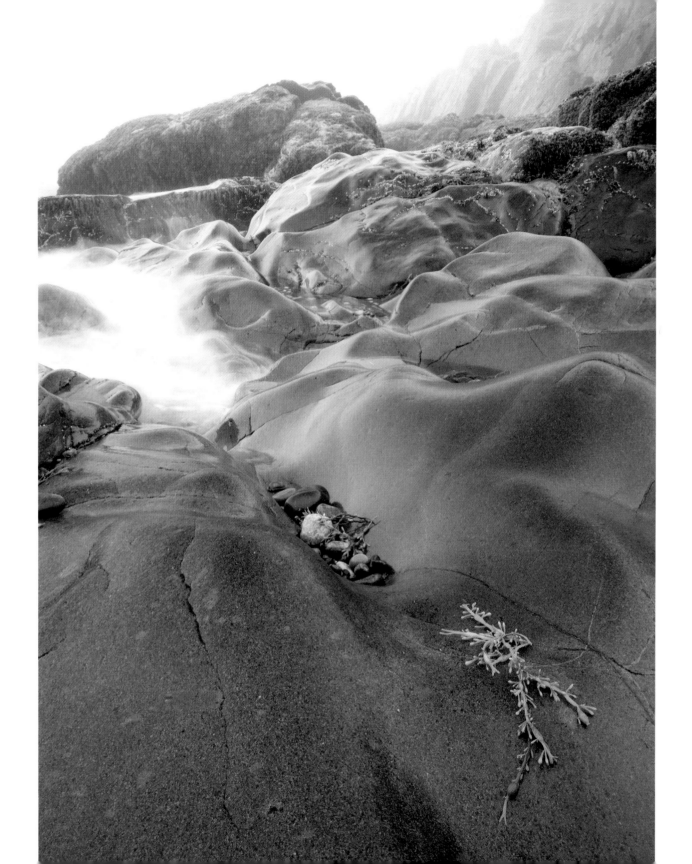

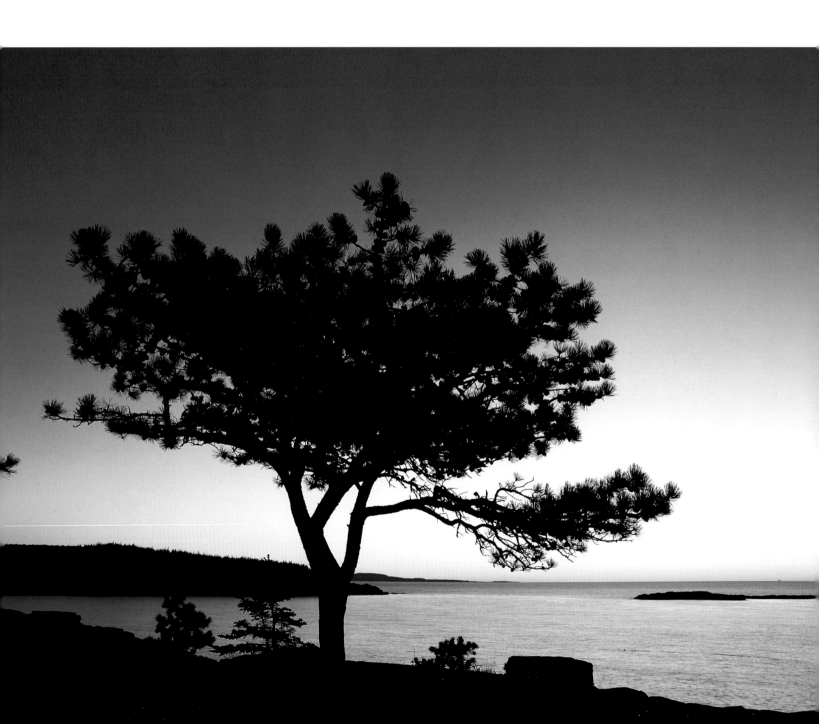

Pitch pine at dawn, Ocean Drive.

crowding, these visitors generate pollution, a disruption of natural patterns, and trampled vegetation. Admittedly, I am part of the problem, though I do my best not to trample anything!

Being a photographer and prone to waking for predawn light, I have spent many a quiet hour in Monument Cove and on Great Head, waiting for the sun to come up with the only interruptions being the call of an eider duck and the thoughts in my head. Not many park visitors see fit to explore the park at 4:00 A.M., so I know it is possible to be alone in this busy park even in some of the most visited locations. Of course, there are always people around later in the morning. The dog walkers and joggers first appear around 6:30 or 7:00, and they are slowly joined by walkers, hikers, and beachgoers until there is a steady stream of foot traffic, which lasts until dinnertime. For me, a visit to Acadia means a lot of things including work, but it always is to some extent about being revitalized, in both mind and body, and that requires at least some moments alone in the wilderness, whether they come during a predawn photo shoot on the coast or a momentary bushwhack up a streambed during a bike ride on the carriage roads. While shooting for this book I became curious about how much solitude is realistically possible in Acadia during the summer months, so one recent late-summer week, in search of true solitude, I ventured to Isle au Haut, an island sanctuary in the park that lies six miles out to sea from the nearest road attached to the mainland.

FINDING SHORELINE SOLITUDE

The view from the rocks above Squeaker Cove was classic Gulf of Maine. On this particular day–September 1, 2005–the blue sky was tempered by an ephemeral layer of white mist, thrown up by a sea churning with eight- to ten-foot surf. Waves crashed on the granite ledges from all directions, as the ocean was more a tumult of confusion than a sea of consistent rolling swells, having been pushed into an angry froth by the remnants of Hurricane Katrina, which passed through the night before. The cool colors of sky, sea, and spruce trees are the perfect accompaniments to the cool, salty air. Clean and wild, this scent felt invigorating and refreshing as opposed to the relaxing comfort of the salty air above the hot summer sand of southern New

England beaches. This moment, I decided, was the essence of Wild Acadia, where nature takes charge and humans are a mere fleeting presence.

My friend John and I stood on the ledges above Squeaker Cover with a need to be refreshed and invigorated. We had just spent a second straight sleepless night in an Isle au Haut lean-to (a.k.a. mosquito shelter), enduring the sounds of driving rain and buffeting winds. We were tired and wet, having hiked around the island the previous two days despite the rain, but we were looking at that blue sky with the hope of warm, dry weather. John planned to hike several miles of trail he had yet to explore, but I had a quieter day in mind. I was searching for a good spot to sit and observe (and maybe nap)—a rock ledge or cobble beach that could serve as my office for the day, with unsurpassed ocean views and quiet solitude. This wild southern end of Isle au Haut promised to be just such a place.

I hiked with John east from Squeaker Cove, past Barred Harbor (with a feeding gray seal and circling bald eagle,) to a small, unnamed cove that is like a smaller version of those found along Acadia's famed Ocean Drive on Mount Desert Island. Extensive pink granite ledges shelter a cobblestone beach where the surf is tempered by small, rocky offshore islands acting as a natural breakwater. Atop the ledges and above the high-tide line on the beach is a forest of deep green spruce trees, their branches draped with old-man's beard lichen, which flutters in the wind like Buddhist prayer flags. The cove faces south, and with the sun gaining altitude and strength I decided to make this my hangout for the day. I quickly took off my shoes and socks, and John said good-bye for the day and left in search of lonely trails and swimming holes. It was 9:30, and despite my "starving artist's" budget I had a million-dollar Maine coast view to myself and all day to soak it in.

Solitude here was not accompanied by quiet, however. Though the cove is sheltered, the sound of crashing surf on the outer ledges and offshore rocks was very loud. The consistent noise quickly became mesmerizing, and I found myself staring west for several minutes watching the spray of waves landing against headlands spouting like the blow of humpback whales, which feed on the shoals near Mount Desert Rock, about sixteen miles east of here. Ravens croaking over the din of the surf broke my trance, and after a few minutes of spreading gear out to dry and

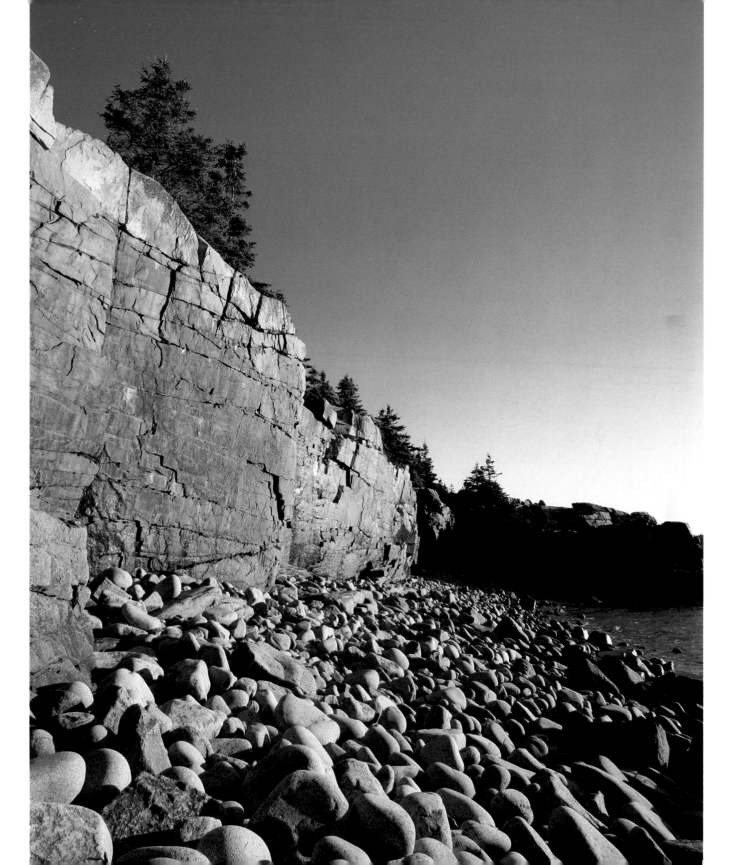

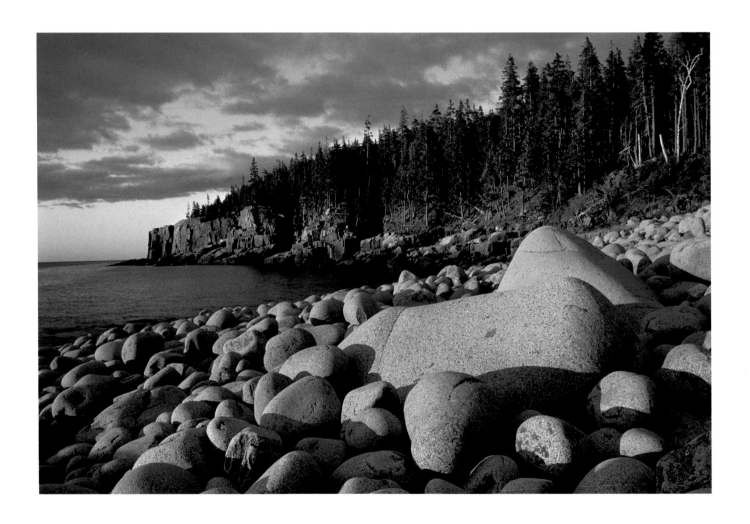

arranging my fleece and pack as a bed on the warm, coarse, pink granite ledge, I am lulled into a welcome, deep sleep by the warm sunshine and sounds of the North Atlantic.

I woke up feeling a bit baked by the hot sun, after managing about ninety minutes of uninterrupted sleep. I worked off my salty grogginess by walking the ledges of the cove and washing the hiking mud off my legs in the cold but soothing water. Getting in and out of the water, though, was harder than I expected. Where the ledges are smooth they are covered by thick, slippery mats of rockweed. I opted to walk in over the cobblestones, but picking my way over wet, bowling-ball-shaped stones was challenging. The cobbles are beautiful and plentiful, but even these stones were considered endangered at one point in Maine's history because they were being overharvested for use as ship ballast and for cobblestone streets and sidewalks up and down the East Coast. Despite the relative homogeneity of the granite ledges in the cove, the cobblestones are a diverse collection of gray, pink, and white rock, some with large crystals, some finely grained. As I worked my way into the water, I could feel the story of this diversity through my feet, which could easily grab onto the rougher, coarse-grained granites but which slipped wildly off the smoother, fine-grained stones. Most of these rocks obviously came from elsewhere on the island, pushed, prodded, and washed into this cove by several millennia of ocean tides.

At this point I had spent about three hours alone here, and I reveled in my own private, wild coastline (although I did think often about how it would be better to share this experience with Marcy, who is back home in Portsmouth carting the kids back and forth, to and from school, during their first week of the semester.) Here I was, within a day's drive and a short boat ride of tens of millions of people, in one of America's most popular national parks; the weather was perfect, and I had an incredibly scenic ocean park all to myself. The only sign of people was a rock cairn built out of cobblestones marking where the trail enters the spruce woods. Even the ocean, void of lobster and fishing boats because of the rough seas, was an unpeopled, mysterious wilderness. This bit of anecdotal evidence suggests to me that, at least on Isle au Haut, the park does not have a problem with over-visitation.

My experiment of trying to spend the entire day alone ended around 1:00, when a man and his eight-year-old son made a quick, five-minute stop in my cove, skipping a couple of rocks and

shooting some video before disappearing back into the woods. I had two more similar five-minute interruptions, once at 2:30 and once at 4:30, but that was it. The rest of my day consisted of reading, writing, breathing, eating, sleeping, and walking. Occasionally, I would hear the ravens or a herring gull, and an immature bald eagle made one brief appearance. The surf quieted as the day went on, and I managed to take only one mediocre photo, a mere record of where I spent my day. At 5:00, I decided to start hiking back to camp. I had spent seven and a half hours in this cove and had seen a total of eight other people, who spent a combined time of fifteen minutes. It had been a rare day of solitude, peace, and wildness.

BACK TO BUSY

Isle au Haut is not Mount Desert Island, and summer on the shoreline of Mount Desert Island is indeed crowded. The parking area at Sand Beach is usually filled with cars before noon, and the Park Loop Road along Ocean Drive is also filled with parked cars and tour buses, its pink ledges busy with picnickers. It can be a little claustrophobic for someone who prefers vacationing in a more wilderness-like environment. Still, the place has jaw-dropping beauty, and with a little effort it is possible to have Isle au Haut–like moments in this part of the park. Fewer people venture to places like Little Hunters Beach and Wonderland, but you will still have company, though they are usually quiet and polite.

One recent August morning I hiked up to Great Head from Sand Beach, scouting some photo ideas. The beach was predictably busy, and the Great Head Trail had a few dozen hikers scurrying about the rocks and peeking over the cliffs down to the blue waters of Frenchman Bay. One of the perks of being a photographer is that your creative brain forces you to seek out perspectives that are unconventional or at least new to a particular scene, and while standing on the ruins of an old teahouse at the summit of Great Head, I decided to look for something interesting to use as a foreground for the dramatic backdrop of the cliffs and the rocky coastline that culminates in Otter Cliffs about two miles away.

This searching took me around the edge of the biggest cliff wall to a little nook of rock out of view of the main trail. This spot was perched about fifty feet above the rocks and water below,

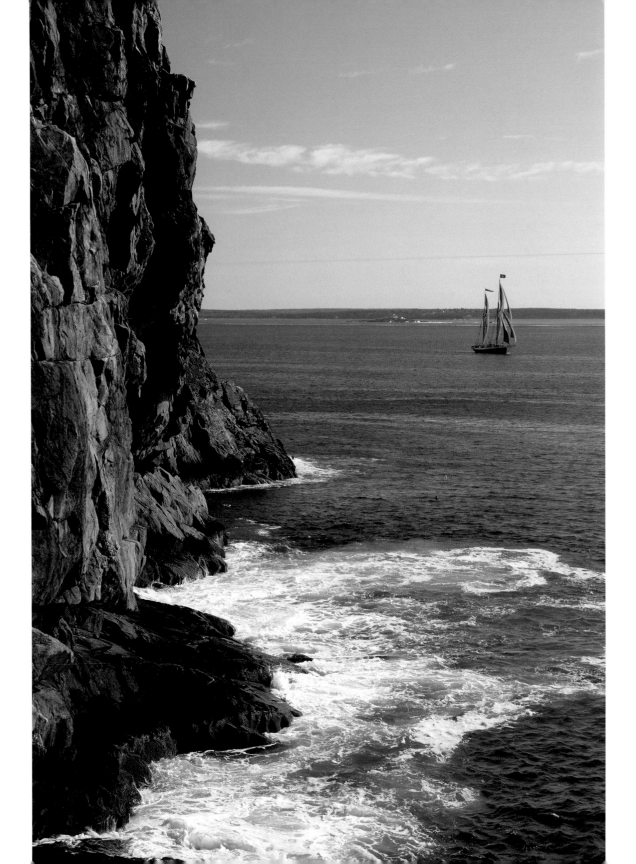

and afforded a great view of the cliff wall that makes up the bulk of Great Head. In this spot I had escaped the sights and sounds of the nearby crowds, and I was able to watch and listen to the bay in peace. I was soon further rewarded when a pod of harbor porpoises spent about ten minutes swimming back and forth about fifty yards off the shoreline below me, feeding on whatever good fish were running that day. The sound of their exhalations was soft but distinct, and it reminded me that despite the immense surge of humanity onshore, the ocean still harbored a quiet wilderness full of wildlife.

After the porpoises swam off, I got to work and explored photo ideas using cliffs, water, and flowers as compositional elements. I am consistently inspired by those flowering plants that manage to live on bare rock, whether it is cliffs like these, constantly battered by winds and salty spray, or the nooks and crannies of rocks in the alpine zone, where those same battering winds work with extreme cold to keep plants from growing. Here on Great Head, the only flowers were goldenrod, bluebells, and three-toothed cinquefoil, but they added just enough color to the landscape to make some interesting photos comprising flowers and the simple elemental subjects of rock, water, and sky.

Amazingly, as I had my camera pointed at Great Head and was just waiting for the right wave to crash on the rocks, a windjammer appeared in the bay, about a mile offshore heading out to sea from Bar Harbor. The ship, with its three masts and under full sail, added a striking active element to my composition that I hadn't even considered while focusing on rock and flowers. I had to quickly fire off a few shots before the schooner moved out of the scene, and the boost of adrenaline I got from this bit of (admittedly mild) excitement had turned up my energy level a notch. I had also lost the ability to concentrate on the scene I had been working to photograph, so I decided to move on to explore more trails and find my next bit of wild inspiration.

Inspiration and artistic expression were the main reasons I was in the park that August day, but Acadia draws its millions of visitors for a host of reasons. Some people come strictly to admire the incredible scenery and watch the diverse collection of wildlife. Others come to test their physical skills on a variety of hiking, climbing, or paddling routes, or to find solitude in a

quiet forest or secluded cove. Still others come here as an excuse to spend quality time with friends and loved ones. Most, including the Monkman family, come for more than one of these reasons and a long list of others that I have not mentioned. Acadia is here for all of us, and though the crowds might keep me away from time to time, I feel privileged to be able to regularly come to this place and seek out those priceless moments of solitude, wilderness, and inspiration that both refresh and define my life.

Looking out at Penobscot Bay from Isle au Haut.

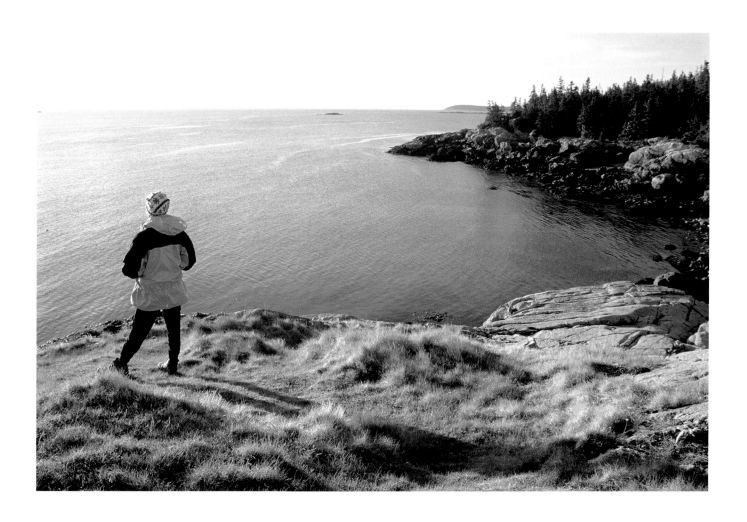

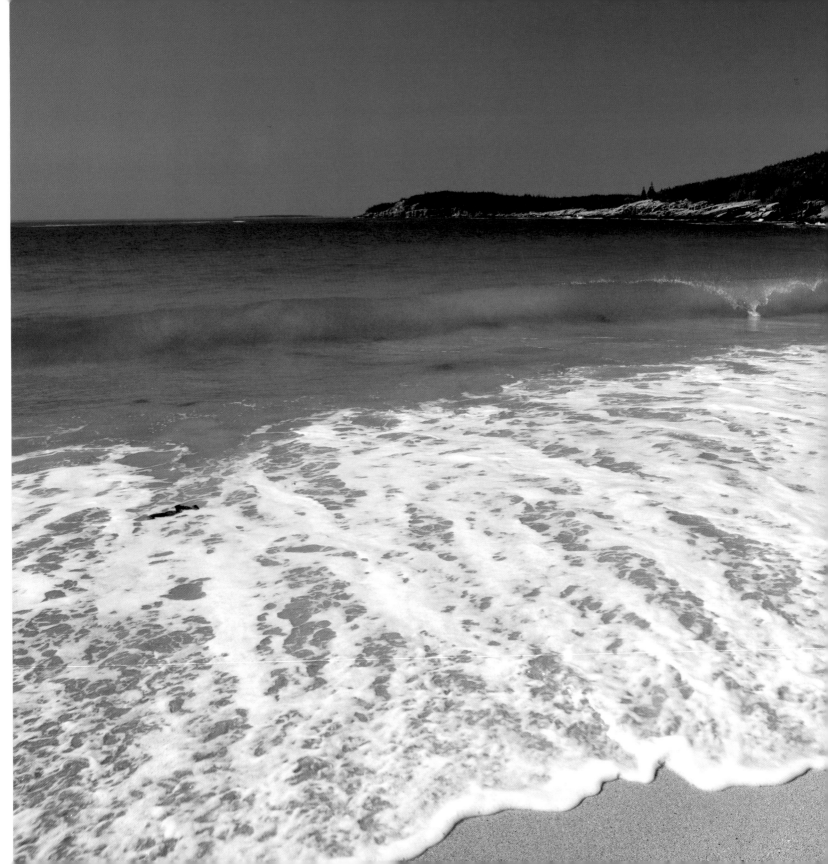

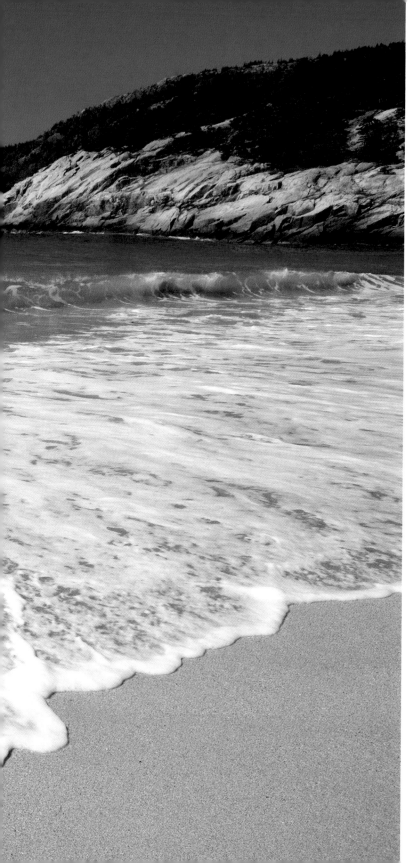

Sand Beach.

OPPOSITE | *Rock ledge, Isle au Haut.*

BELOW | *Crab shell, Sand Beach.*

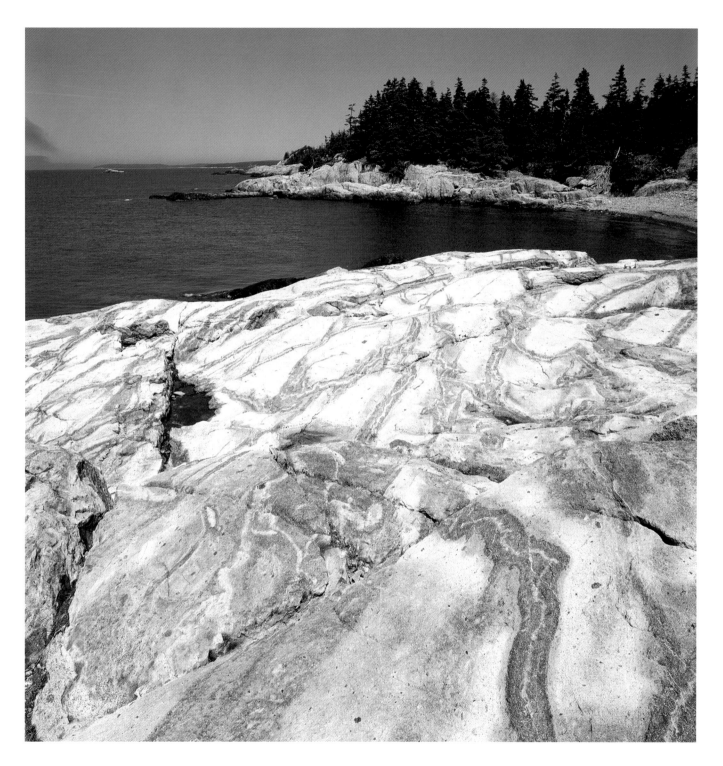

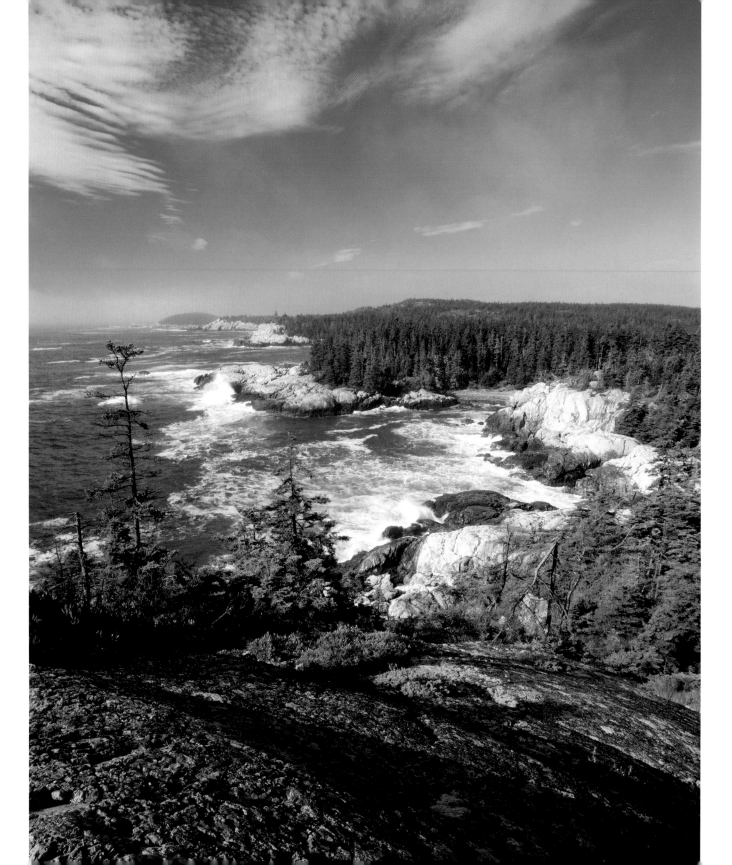

OPPOSITE | *Squeaker Cove, Isle au Haut.*

BELOW | *Mount Desert Island from Sutton Island.*

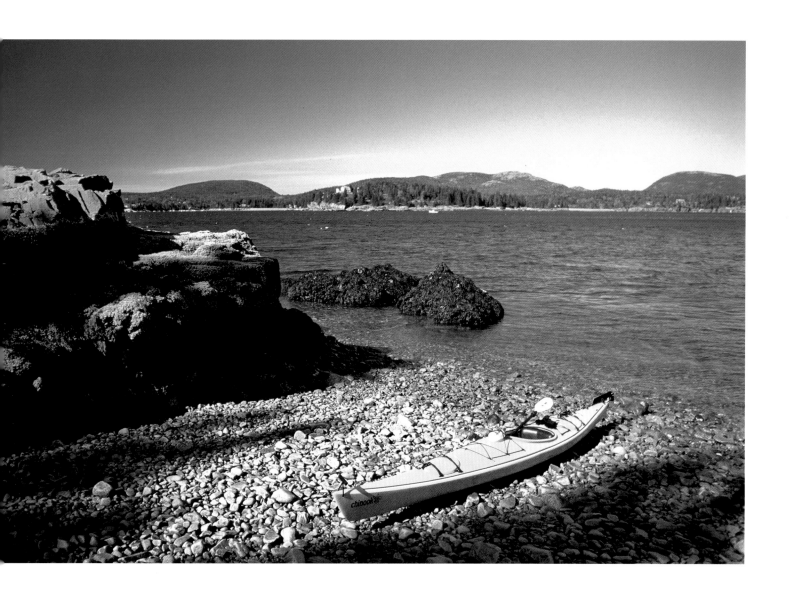

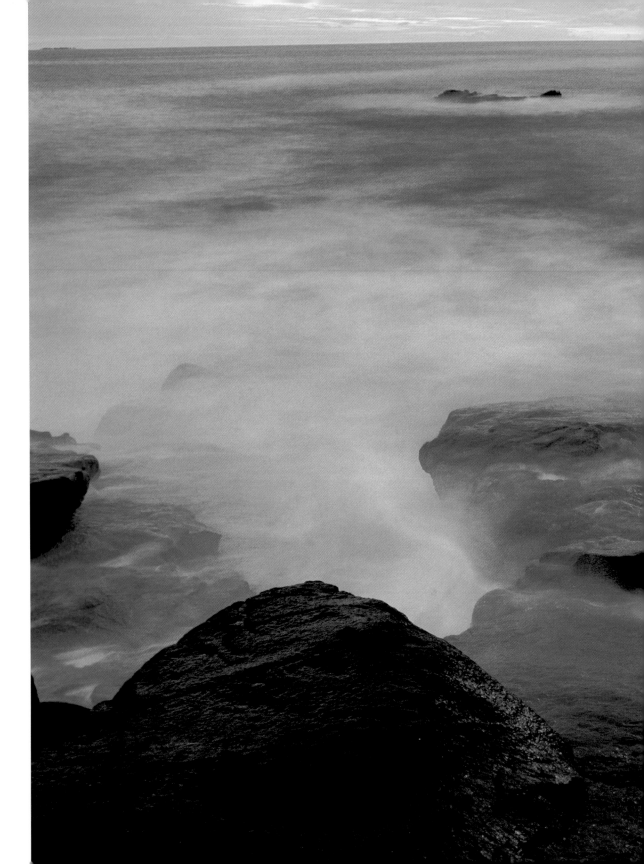

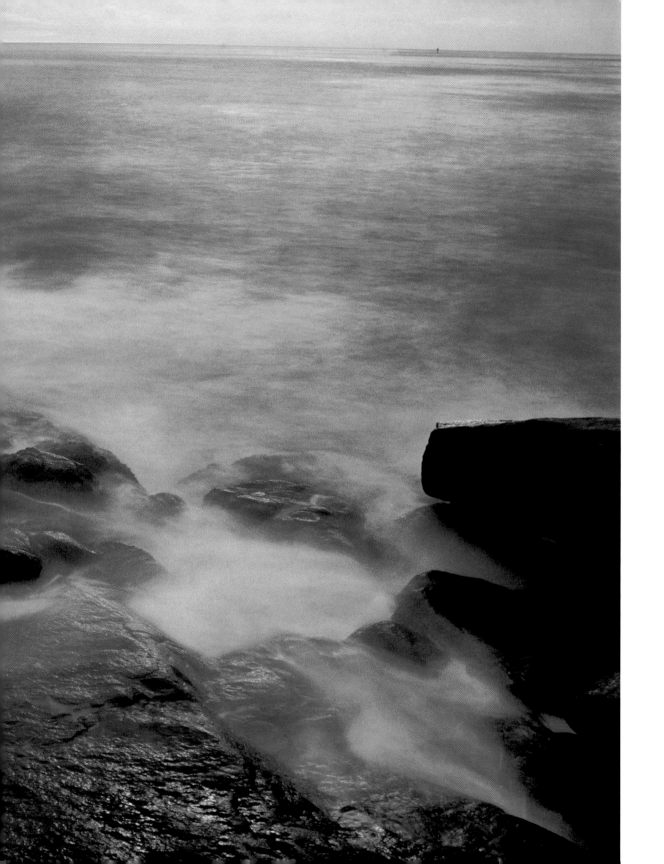

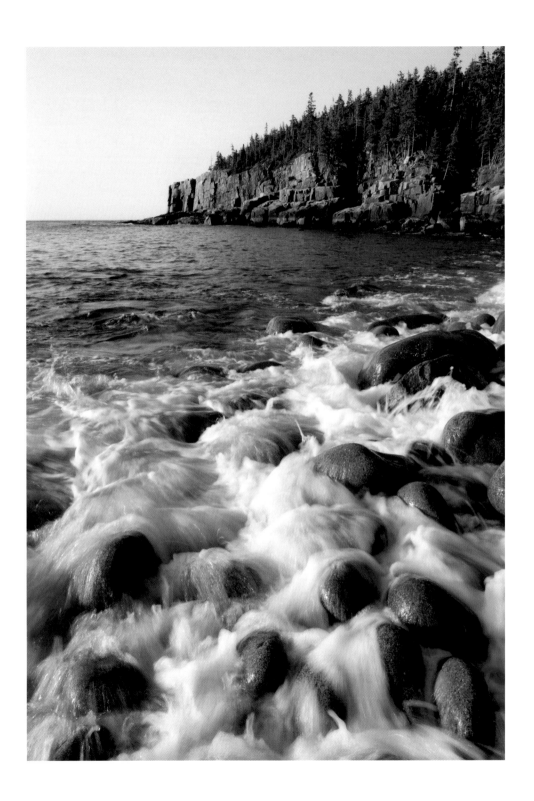

Bass Harbor Head Light, Valentine's Day.

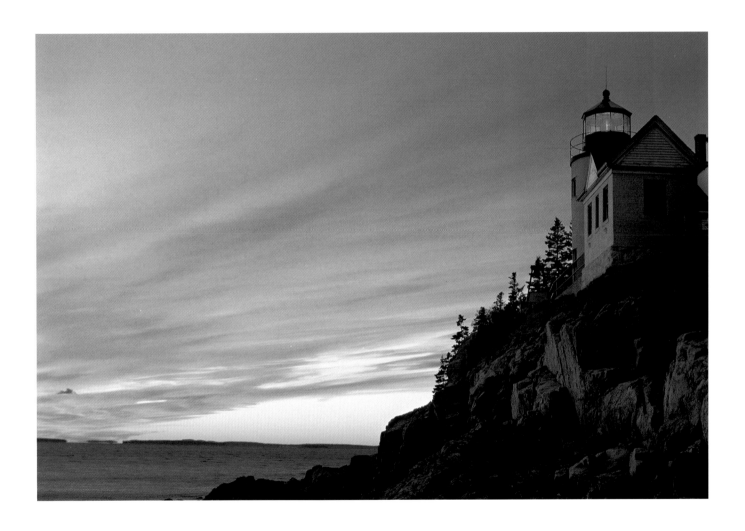

Forests

IT IS ALWAYS DARK IN THE WOODS AT DAWN, but it was especially dark in the spruce forests below Parkman Mountain on one overcast October morning as I walked the carriage roads wondering what had happened to the forecast blue sky. My day of solitude on Isle au Haut had me wondering if a similar quiet day was possible on Mount Desert Island, where the majority of Acadia's two-million-plus annual visitors spend their time. I knew that somewhere like Sand Beach in summer would never be quiet for an entire day so I decided to get a little lost in the woods during peak foliage season. The park would be busy with leaf peepers, but I was curious how quiet the woods would be if I got a couple of miles away from the nearest road. Very quiet it turns out, and without much effort.

My plan was to spend the day in a small, triangular piece of forest bordered by a carriage road on the north, the Hadlock Brook Trail on the east, and the Maple Spring Trail on the west. Both trails follow branches of Hadlock Brook, which drains the western slopes of Sargent and Penobscot mountains and flows via the Hadlock Ponds into Somes Sound across from Flying Mountain. The area containing my "forest for a day" is probably less than one hundred acres in size, but I have many times marveled at the big eastern hemlocks and white pines here that can be seen from a pair of bridges on the carriage road. A forest fire that burned more than half of the eastern side of the island in 1947 never made it to this part of the park, so I was hoping there would be more of the big trees hidden downstream from the carriage road. Part of my plan was to photograph these big trees with streaks of early morning sunshine cascading through the canopy, but the fickle Maine coast weather made that impossible on this day.

Getting to this forest is easy. It is a relatively flat carriage road walk of less than a mile from the Parkman Mountain parking area on Maine Route 3 to Hemlock Bridge, just one beautiful example of the handmade stone bridges that can be found throughout the park's carriage road system. Another two hundred yards or so farther east on the carriage road is Waterfall Bridge and its equally attractive stonework, complete with viewing turrets and an archway that perfectly frames the waterfall that gives the bridge its name. I spent about an hour walking back and forth between the bridges, making pictures of the waterfall and a mini granite gorge that lies just upstream of Hemlock Bridge. Around 8:00 A.M., as the day finally began to brighten, I was

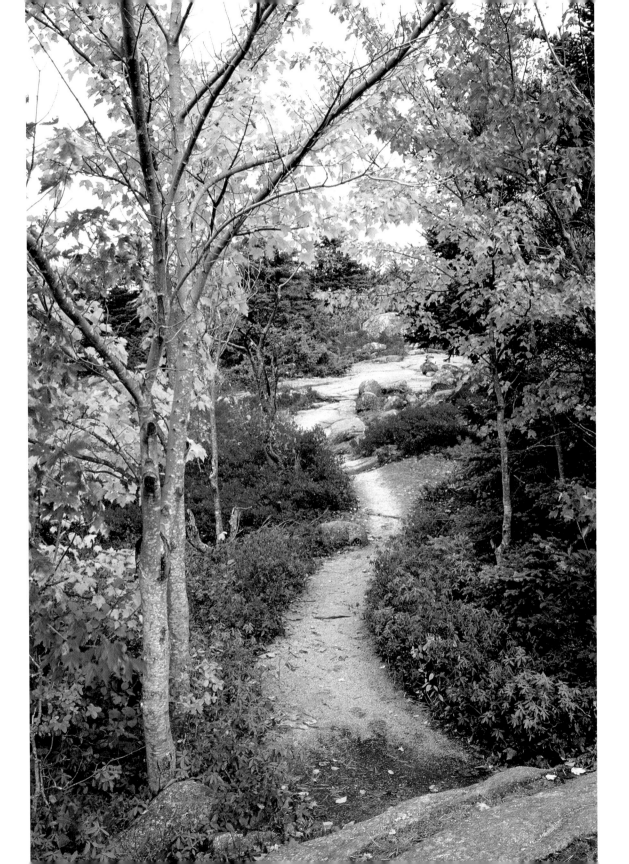

surprised by a pair of bicyclists who go whizzing by. I had forgotten that I was not alone on this island.

I took this as my cue to leave the carriage road and explore the trails along the brook. I followed the Hadlock Brook Trail downstream for no more than five minutes before I found myself

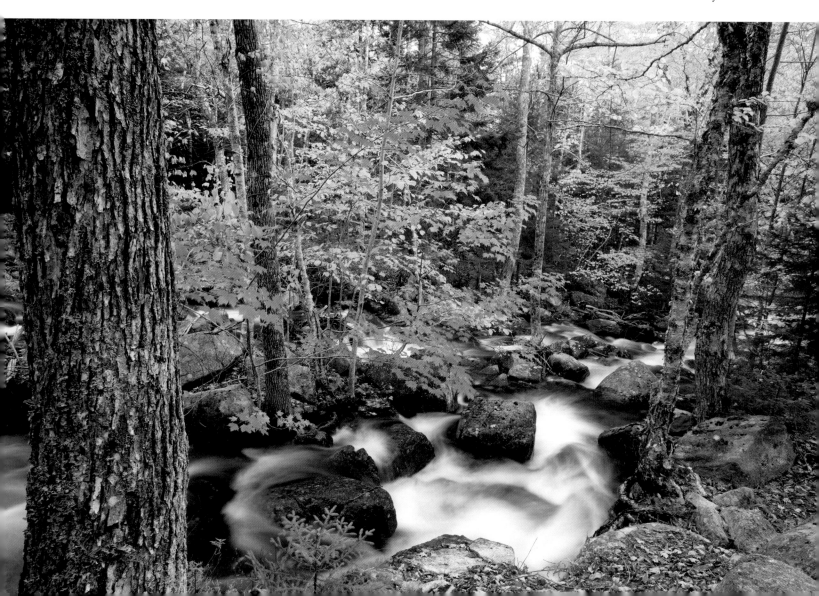

sitting on a granite ledge next to tumbling water, using the trunk of a massive white pine as a backrest. The tree is no less than thirty inches in diameter, with roots thicker than my thighs wrapping around the sides of my rock platform. All sound was drowned out by the falling water and the leaves rustling in a fifteen-mile-an-hour breeze. The breeze adds a little chill to the fifty-degree air, but this was a comfortable spot and I was warm wearing a sweatshirt and light wind-breaker, the wind, the air, and the leaves conjuring visions of high school football games, apple crisp, and wood smoke. I leisurely wrote some notes (which eventually became this essay), took a drag from my Nalgene bottle, and continued on downstream.

As the trail wanders a dozen or so yards away from the stream, I realized that the water and leaves are not drowning out the forest sounds after all, as the woods are silent save for the shuffl-ing of my feet through the fallen leaves of maples and birches. In spring, the forests of Acadia are filled with a cacophony of birdsong as more than one hundred species of birds nest here, includ-ing twenty-one species of warblers, but it had been months since these birds courted, built nests, and fledged their young, and most had already begun their migration to warmer forests in the Carolinas or Texas or Guatemala. As my walk took me through a grove of red spruce, I found a little action—the chatter of a red squirrel and the peeps of black-capped chickadees. (Later in the day I would hear the screech of a red-tailed hawk, but as long as I was in the woods, away from the carriage road, I would neither see nor hear any signs of people.)

For lunch I rested against another big white pine next to the stream in an area where the land flattens out. It is obvious that, in higher water, the stream easily overflows its banks and spreads out. There are several dry, gravelly channels that cut through a maze of big conifers. In addition to white pines, there are some very big red spruce trees and Atlantic white cedars. The cedars are probably the biggest I have seen in Maine. The forest here has obviously been allowed to grow without cutting for a long time, probably at least since before John Rockefeller, Jr., bought this part of the island in the 1920s. With a belly full of peanut butter and jelly, the beauty of the for-est and the sounds of the tumbling brook quickly hypnotized me, and I drifted off to sleep.

I didn't nap long, but when I woke up I groggily stared at the big conifers that hug the water-course. Looking about twenty yards to drier land, I noticed a healthy northern hardwood forest

of red and sugar maples, yellow and white birch, witch hazel, ash, hobblebush, and bigtooth aspen. Though I can't find a scientist to admit there is old-growth forest on the island (seemingly all the forest was at one time cut for timber, for firewood, or to create farmland), these woods feel old. The ground has a deep and very soft layer of decaying humus—leaves, pines needles, and rotting wood. Big trees have fallen and been left to rot, and the ages of the trees vary greatly, creating an uneven-aged stand of trees that is the hallmark of late-successional and old-growth forests. Other indicators of an old forest that I found are a healthy population of red-backed salamanders (they seem to be hiding under every rotten log I overturn) and *Lobaria pulmonaria*, a beautiful, leafy lichen that in Maine tends to colonize the bark of sugar maples more than ninety years old.

I focused my camera on the lichens, which seemed more interesting than the foliage of the hardwoods. A very warm fall had delayed the leaf change, which doesn't really get under way until there is a good hard frost, so even though it was October 13, the leaves were primarily green with a few dull yellows and browns. The lichens, however, had an unlimited range of luscious greens, blues, and grays, with an equally stunning diversity of textures, and I spent a good thirty minutes consumed with compositions found on the bark of just one old sugar maple. (The foliage of the hardwoods, in contrast, would never quite capture my attention that fall, as the unusually warm weather was followed by torrential rains and heavy winds that ripped a lot of the leaves from the trees before they had a chance to startle us with their brilliant hues of crimson, orange, and gold.)

As my concentration on photographing waned, I once again noticed the silence. It was 3:00 in the afternoon, and I had not seen a soul since I left the carriage road seven hours earlier, the big trees and mossy ground dampening any indication that there might be a world outside this forest. I decided the day was a success, and my head started to fill with thoughts of playing with my kids and enjoying a good dinner with them and Marcy back at the apartment we have rented in Bar Harbor. I walked back to Hemlock Bridge, chatted briefly with another photographer newly taken with the scene of rock, water, and wood, and made the quick trip back to civilization, once again refreshed by a day of solitude in the depths of Wild Acadia.

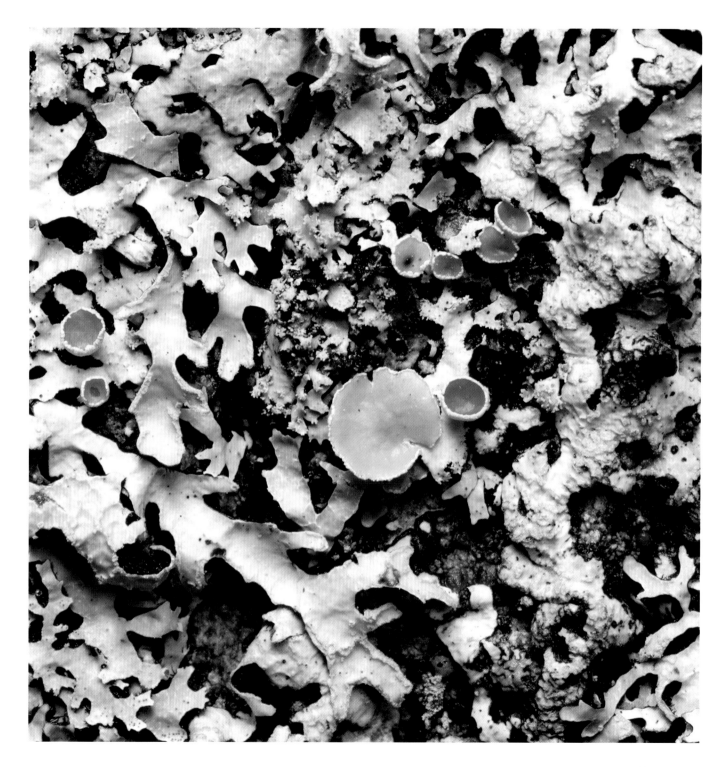

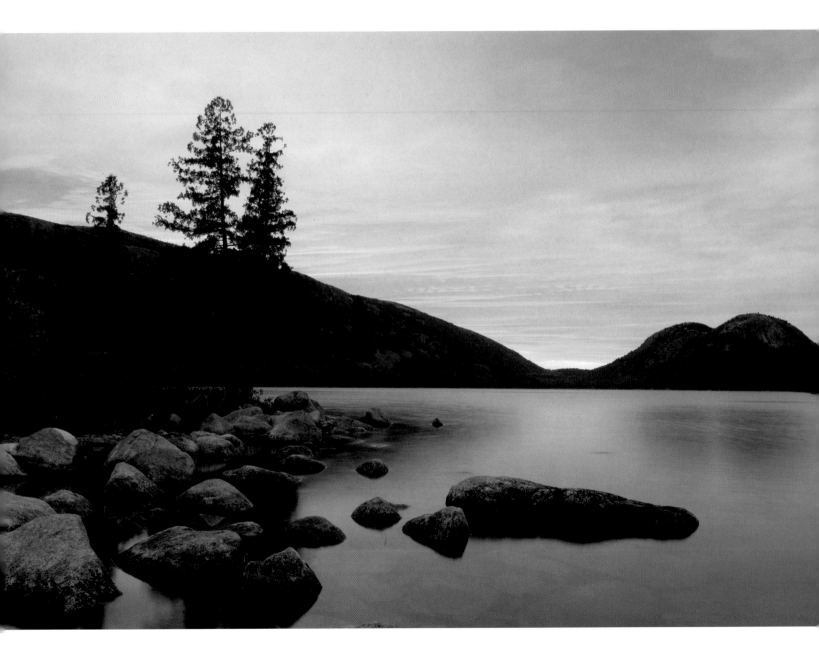

MORE FORESTS

There are other forests in Acadia, some dark, some bright, some tall, some relatively short. The spruce forests on Isle au Haut, flush with constant moisture from the Gulf of Maine, are some of the darkest, greenest forests in New England, the stands of tall trees rising above a thick mat of glossy moss, with only an occasional interruption of sphagnum wetlands full of pitcher plants, sundew, and silvery, dead tree trunks standing in the muck. And of course there are the spruce-fir forests on the western side of Mount Desert Island that are reminiscent of so many high-elevation forests in northern New England, the closely spaced red spruce and balsam fir trees creating the illusion of an impenetrable forest from afar and, as on Isle au Haut, yielding only to water, in this case the tidal creeks that push in and out from the sea.

Where things look really different is on the eastern side of Mount Desert Island, where the fire of 1947 dramatically altered the makeup of the forests. In many of the fire areas, the predominant spruce-fir forest has been replaced with a recovering forest that has a mosaic of tree species, primarily those that populate disturbed areas, including white pines, white birch, and bigtooth aspen. Sugar maples, northern red oak, and eastern hemlock are also common in these forests. The resulting diversity of tree species has attracted a greater diversity of wildlife, including beavers, which feed on the young hardwood saplings and are much more common in the park than they were a hundred years ago. The beavers have created additional wetlands in the park, which in turn have caused an increase in aquatic animals, such as crayfish and amphibians, and those that prey on them, such as herons, kingfishers, and river otters.

In some places the fire burned so hot that it sterilized the soil, or winter rains washed away what soil was left, and it took years for trees to return. You can still find areas (for example, along Duck Brook Road and the eastern slopes of the Beehive and Gorham Mountain near Sand Beach), sixty years later, where only spindly white birch trees have managed to grow, and many of those trees have started dying off after being heavily damaged during winter storms. One forest type that the fire actually benefited is the pitch pine forest, which is found on the rounded granite peaks and open rock ledges of the park. Here the soil was already scarce, and the fires helped to rejuvenate and spread the fire-resistant pitch pine trees, creating a landscape of pink rock and

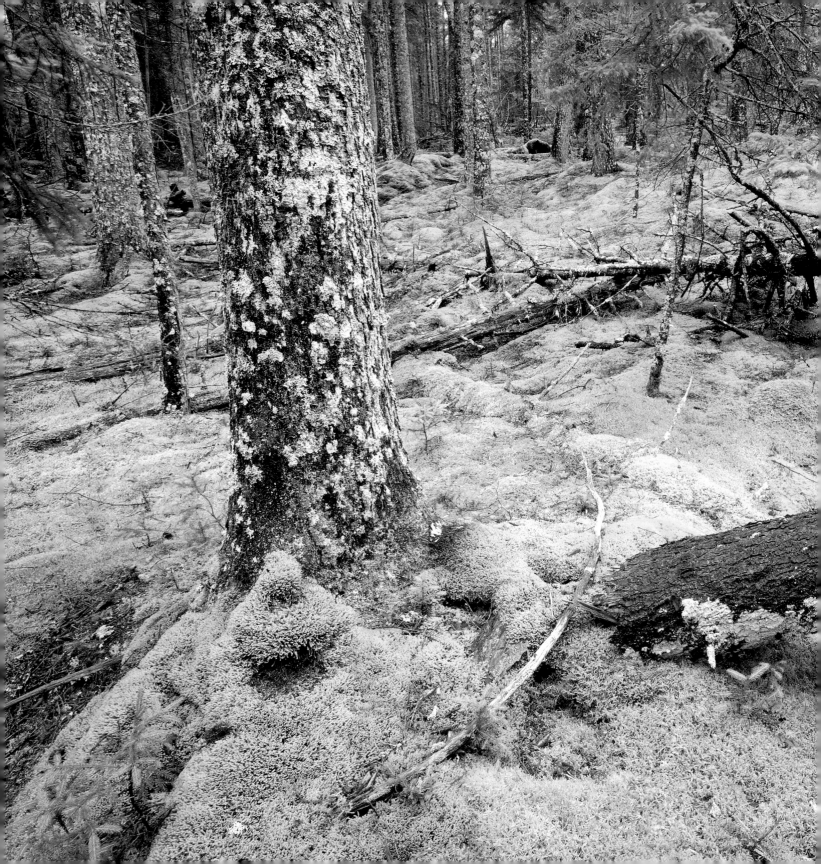

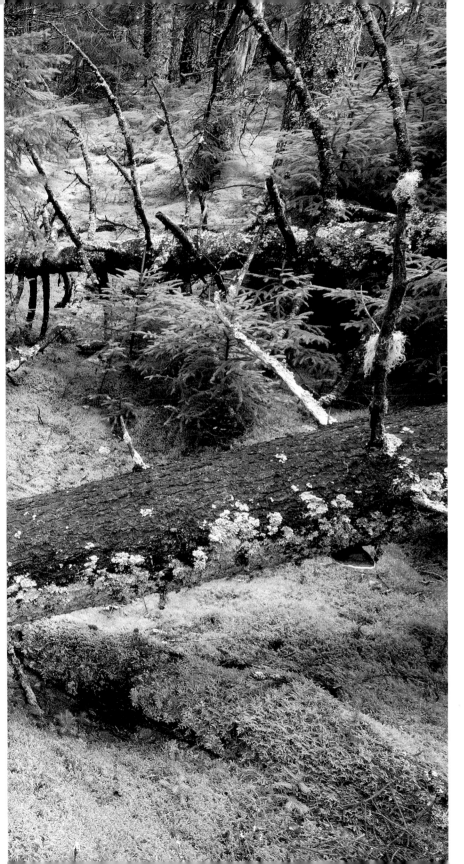

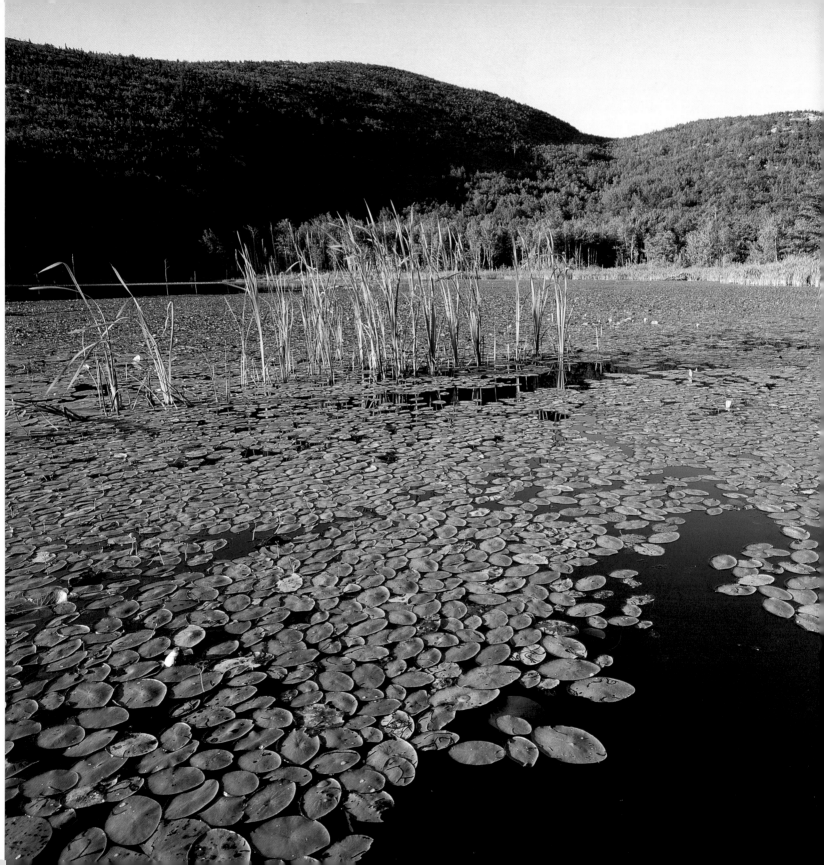

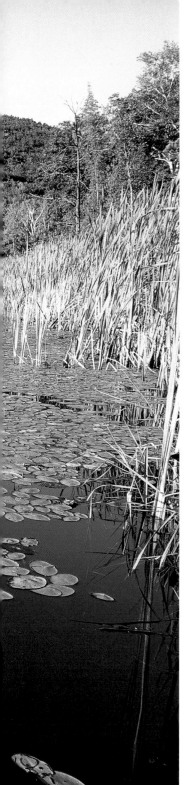

Lily pads and cattails in Beaver Pond.

to note that, in a busy park like Acadia, where you choose to spend your day determines how quiet your time will be. Not only is the choice between shoreline, mountain, or forest but also between busy hot spots and quiet out of the way places—between, say, less visited coves and crowded beaches, or popular Cadillac Mountain and little-visited Bernard Mountain, or an open pitch pine forest and a lushly quiet, old valley forest. Right now, I am grateful to have all these places to choose from.

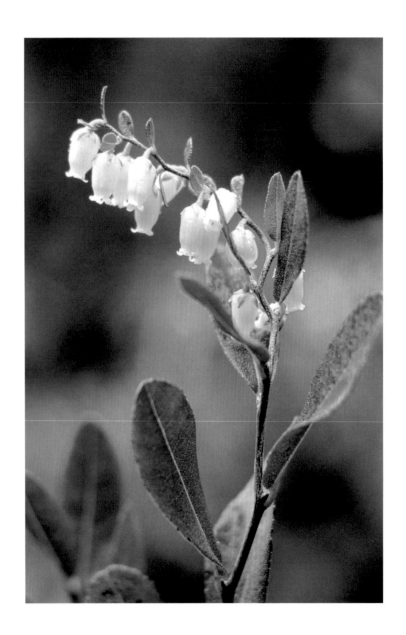

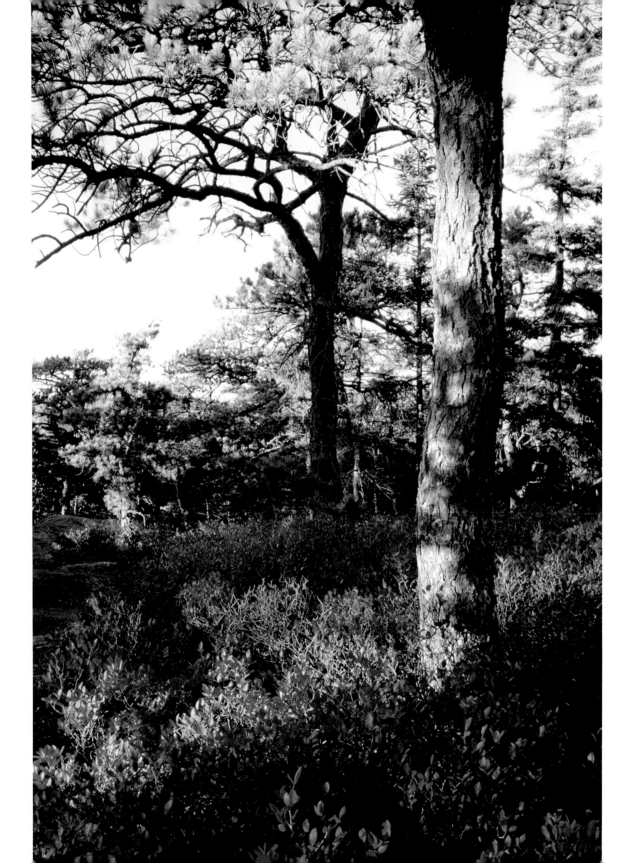

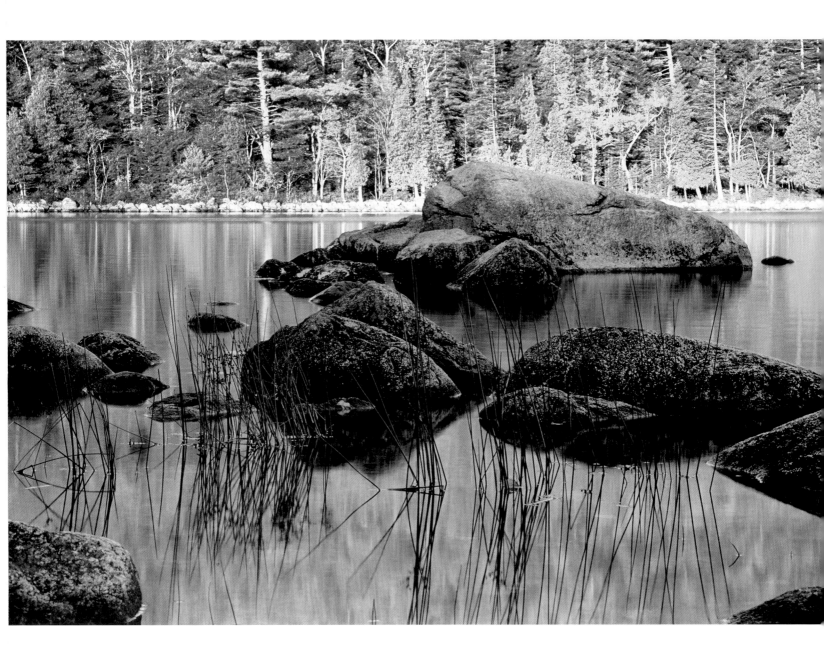

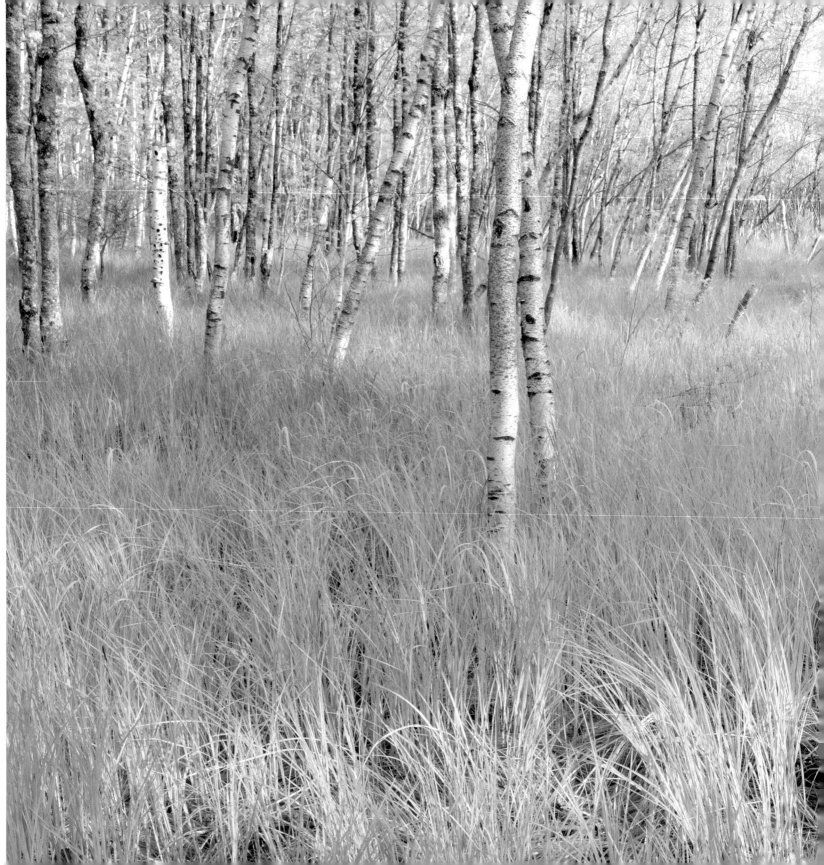

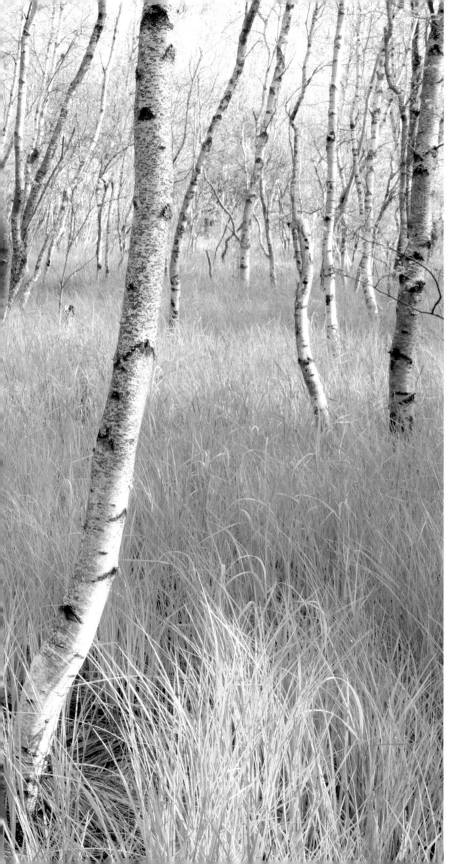

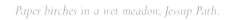

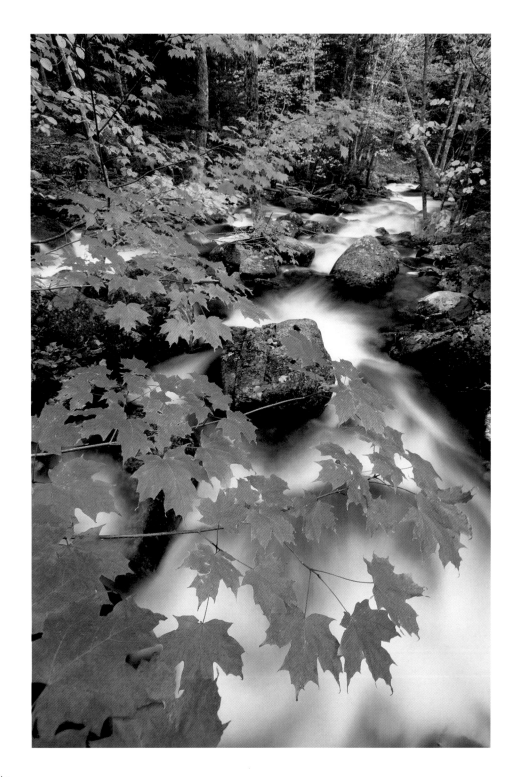

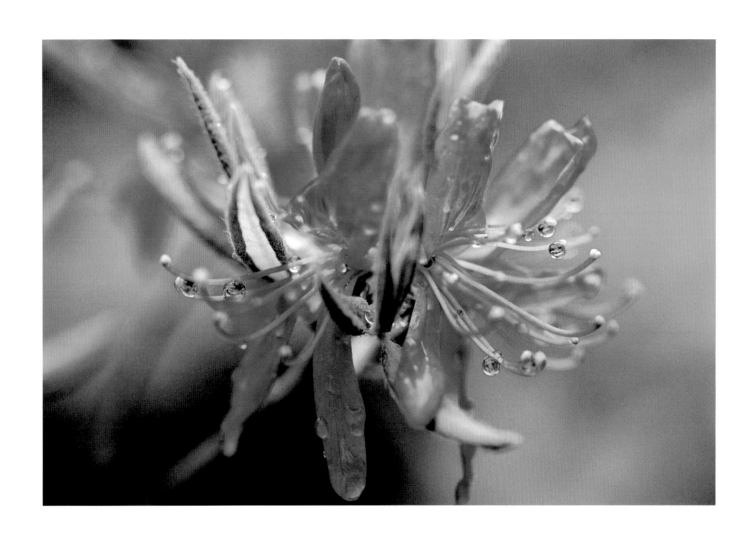

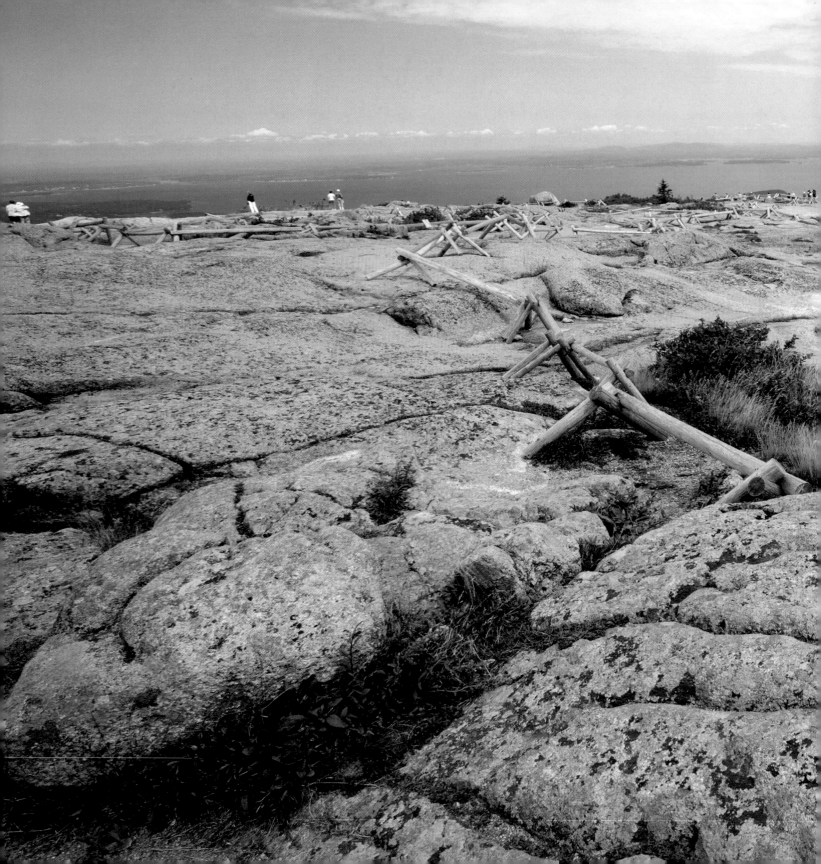

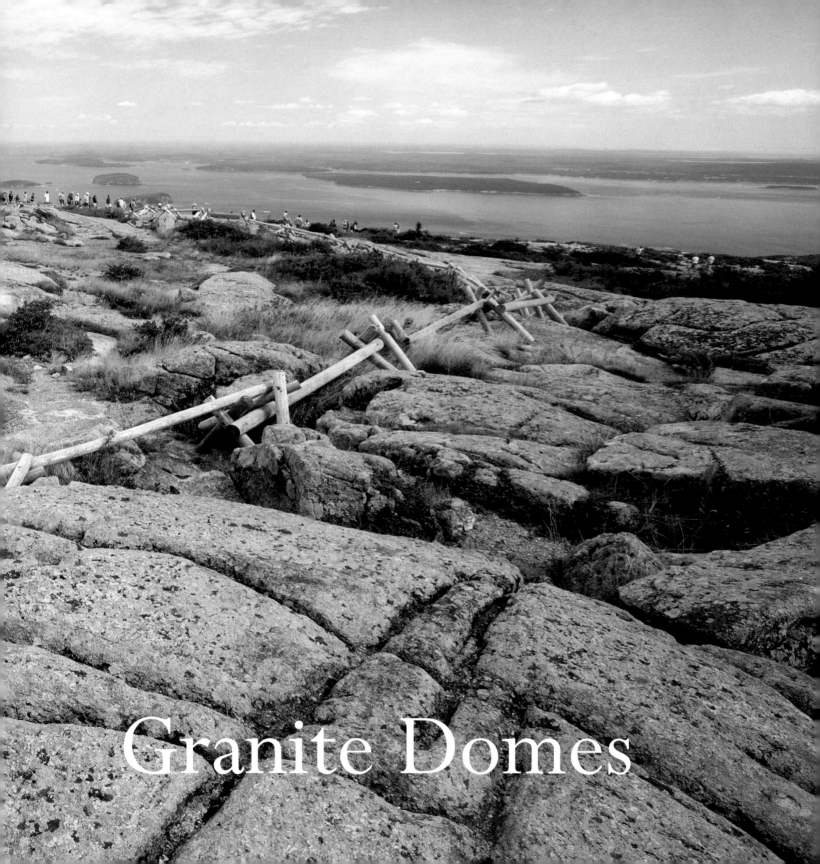

Granite Domes

ALL I COULD SEE as I hiked up the north ridge of Cadillac Mountain in the dark is the small circle of light thrown by my headlamp, but my other senses had no problem detecting that it was August in Maine. The air had a smell of salt that is occasionally covered up by the luscious scents of blueberries and sweet fern, and over the sound of my own breathing I could hear the soft thump of my Vibram soles on granite, as well as aspen leaves rattling in the wind and the buzz of cicadas, whose oversize insect calls seem to conjure memories from every summer of my life. In about thirty minutes the first cracks of light will hit the eastern horizon, but still I hurried, hoping to make it to the summit in time for sunrise.

Even though I have watched sunrise from the summit of Cadillac probably a dozen times before, it still feels special because each day this is the first place in the United States to be graced by morning sunshine (most of the time, anyway, as Mount Katahdin holds that distinction for a few days of the year). And it always feels better to see this sunrise after a hike in the dark instead of after a drive up in the car. After about forty minutes of hiking, I stepped out of the trees, with daylight breaking on the horizon, and the sounds of cars filtering through the buzzing cicadas and my active breathing. When I reached the summit, the parking lot was completely full of cars, and a few hundred people were spread out facing east, some standing, some cuddled under borrowed hotel blankets, some sipping lattes in their lawn chairs. Electronic flashes fired off like it was a U2 concert at the Fleet Center, and I scurried like a deer mouse looking for my own little nook to set up a tripod and photograph the rising sun.

For this sunrise, I was prepared to make any spectacular photos that might happen (none did), but I was also intent on spending the entire day on the summit to study just how crowded this place is. I have been on the mountain enough in the summer to know that it always hosts a lot of human activity, but I thought there must be some downtimes. It turned out that on the day in August that I visited, there were no downtimes, at least not during the daylight hours.

According to the National Park Service, Acadia National Park was visited by 2.05 million people in 2005, making it the tenth-most-visited national park in the country. That was 775,000 more people than the population of the entire state of Maine. The park itself covers a total of 48,000 acres, so the total annual visitation represented 42 visitors for every acre in the park. In

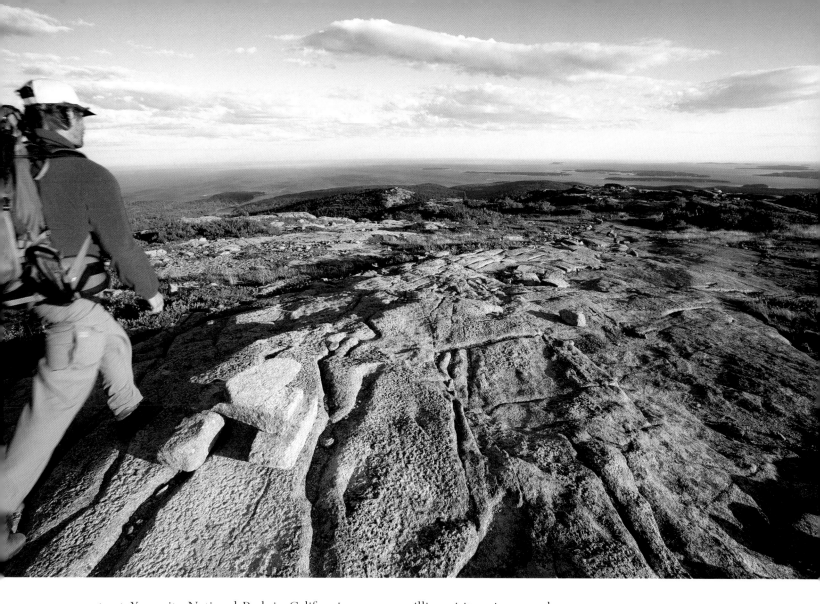

contrast, Yosemite National Park in California saw 3.3 million visitors in 2005, but at 750,000 acres that park had an average of only 4.4 visitors per acre. Like Acadia, Yosemite is plagued with problems of overuse, primarily because most of its visitors are funneled into Yosemite Valley. But unlike Acadia, Yosemite has hundreds of thousands of acres of backcountry to get lost in, as well as millions of acres of abutting national forest land.

Acadia's visitors, like Yosemite's, tend to concentrate in the most popular and scenic parts of the park: Sand Beach and Ocean Drive, Jordan Pond, and Cadillac Mountain. Unlike Yosemite, Acadia does not have a vast reservoir of backcountry lands that can handle some of the excess visitation; and the park is surrounded by private, not public, lands; and much of that private land is

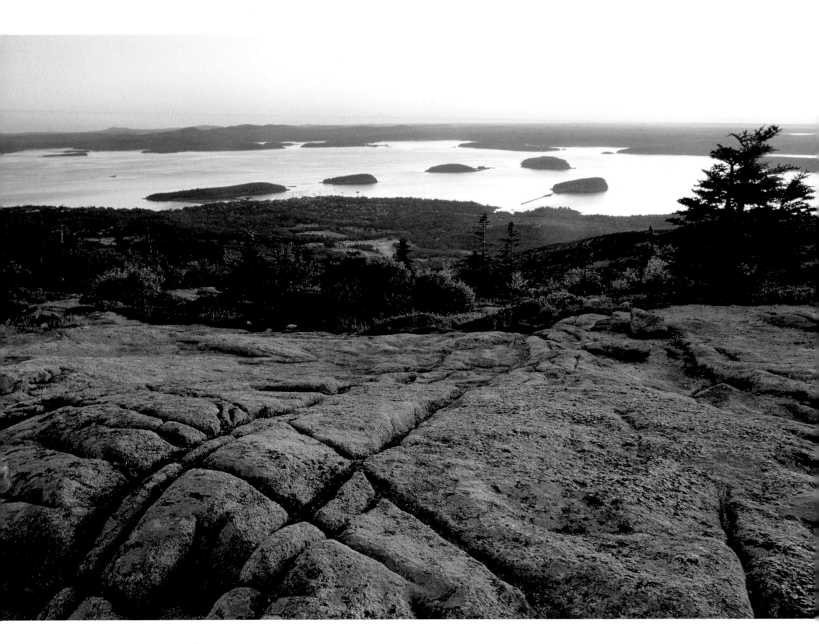

The Porcupine Islands at sunrise, as seen from the summit of Cadillac Mountain.

being developed at a quick pace. Acadia is an island within Mount Desert Island (not counting the outlying parcels of the park, of course), and though it was created through the generosity of private individuals who saw the value of protecting the mountains and shorelines of the island, the lands that make up the park are increasingly being hemmed in by roads, condos, and hotels being built by landowners with less long-term vision than their predecessors. The very core of what brings people to the island (quiet shorelines, beautiful mountain forests, abundant wildlife) is being compromised by our desires to live in and profit from this paradise. Of course, this not a problem unique to Acadia, but to me it seems especially poignant here because the physical decline of the island's wildlands and solitude is exactly what the creators of the park were fighting so hard to prevent a hundred years ago.

So does the park really feel crowded? As chapters 2 and 3 of this book point out, it is relatively easy to find quiet and solitude in Acadia if you want to, but you have to carefully choose the time and place of your visit. During my day on Cadillac Mountain, not a moment passed on the summit when I did not hear one of the following: car doors slamming, children crying, people talking, diesel engines rumbling, cell phones ringing, walkie talkies, cars starting, car alarms, car horns. A few natural sounds did filter through the din of civilization—the clicking of grasshoppers, the calls of ravens, the wing beats of a herring gull—but I definitely felt like I could just as easily have been at a mall.

All this noise happens in a beautiful place, of course—that's why the crowd is there, and it is why I am often part of the crowd. Looking away from the parking lot and gift shop, I focused my eyes on the deep blue waters of Frenchman Bay and the emerald green Porcupine Islands. Classic puffy summer clouds floated across the sky, and I saw circling vultures and a sharp-shinned hawk flying west with a seeming sense of urgency. Twisted firs stood above pink, lichen-encrusted granite chiseled smooth by centuries of moving ice and water, and mustard yellow goldenrod bloomed wherever enough soil has collected in the cracks in the rock.

As it turns out, a lot less soil remains on the summit of Cadillac than in past years, because of all the foot traffic there. It is easy to see how much soil has been lost by looking at where the map lichen grows on the rocks. This green, crustose lichen usually grows down to soil level, but

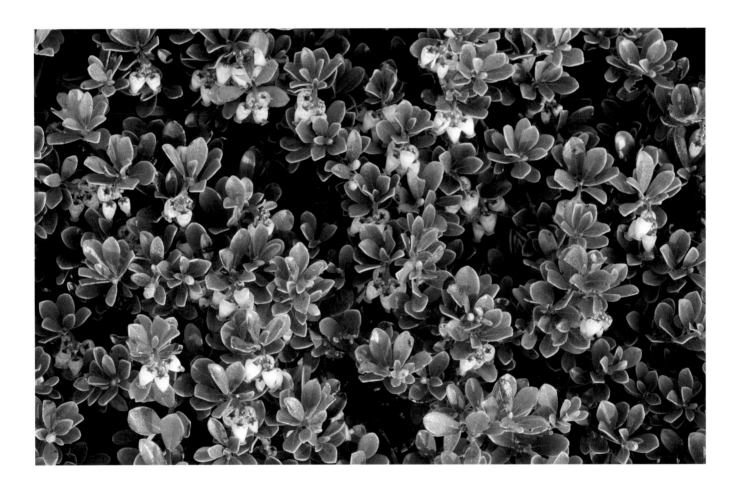

Fortunately, Acadia's present includes more than an overcrowded mountaintop. Even Cadillac Mountain offers quiet and wildness. By 5:00 P.M. of my day on the summit, I was a little bored with the parking lot and gift shop and wandered south along Cadillac's South Ridge Trail in search of a mental break and maybe a picture or two. Within ten minutes, I was alone on the mountain's wide open southern shoulder, taking in the spectacular views of the park's western mountains, the blue waters of Frenchman Bay, and the Schoodic Peninsula.

As on most of the granite domes in the park, the pink rock on Cadillac is scarred by glacial striations, grooves cut into the rock by other rocks that were dragged across the mountain by glaciers in the last ice age. A few cedar and spruce, stunted by thin soils and winter winds, live in the most sheltered places, while a few wildflowers, lowbush blueberry, and prostrate Bar Harbor juniper hug the nooks and crannies around boulders. In the few places where there is enough of a depression for soil and water to collect, there are sedges and sheep laurel and Labrador tea. It feels like an alpine environment, even though the mountains are relatively low in elevation. In stormy weather, the domes are wet, cold, and sometimes a little scary. On a warm sunny day, glorious.

This August day was one of the glorious ones. The air was warm, the slight breeze was salty, and I decided that maybe it is a good thing that there is a road up Cadillac Mountain and that the majority of visitors who find their way to the top of one of Acadia's peaks do so there. The heavy use is concentrated in one place, and the rest of us who want to experience a little less humanity can easily do so by just walking away. How simple. I wandered somewhat aimlessly along the ridge looking for a "grand landscape" I could photograph, but I found myself increasingly drawn to the little things rather than the big-picture views of blue waters and green islands. The exposed bedrock that the trail traverses is the usual Cadillac granite. It is well worn but still beautiful with its rosy coloring, flecked with black, white, and gray crystals. Rocks to the side of the trail are covered in bright green map lichen as well as three or four other lichen species. By rock-hopping away from the trail, I found undisturbed earth covered in blue-green reindeer lichen and the distinctive waxy evergreen leaves of bearberry. The colors and textures of the plants and rocks would easily have provided enough photo material for the rest of the daylight hours, and I probably would have stayed until dark if my attention had not been drawn skyward, first by circling turkey vultures and then by the streaking form of a peregrine falcon.

Peregrines were successfully reintroduced to the park in the 1980s after a thirty-year absence (peregrine numbers plummeted nationwide in the 1950s and 1960s because of the widespread use of pesticides, which caused the thinning of eggshells to the point where the birds could no longer reproduce). The birds now regularly nest on several cliffs in the park, most notably on the

east face of Champlain Mountain, just two mountains away from Cadillac. Peregrines prefer to nest on small ledges high up vertical cliff walls, where the threat of predators is small and where their view of prey, mainly ducks and other birds, is unobstructed. This habitat abounds in Acadia. The peregrine I saw on Cadillac was the latest of several noteworthy sightings I have had in the park in places like the summit of Champlain, the trail around Jordan Pond, and the ledges on Eagle Cliff high above Somes Sound.

The Eagle Cliff sighting is my most memorable one. Eagle Cliff rises five hundred feet straight up from the shores of Valley Cove in Somes Sound, and the top of the cliff, only a few hundred vertical feet below the summit of Saint Sauveur Mountain, is easily accessible via a hiking trail that climbs up the backside of the cliff from the Valley Cove parking area. However, going up or down the cliff is impossible without climbing gear, and that's what makes it so attractive to peregrines. The birds have regularly used this cliff since their reintroduction.

One October afternoon I was standing on the trail near the top of the cliff, with my camera on a tripod pointed out toward Flying Mountain and the entrance to Somes Sound, when a pair of falcons effortlessly rode a thermal up the side of the cliff face to a point several hundred feet above me, where they circled quietly for a minute or two. Without warning one of the birds tucked in its wings and dove straight down. Within two or three seconds it was gone, out of sight somewhere below the cliff, probably smashing into some poor, unsuspecting mallard or starling. Peregrines are regularly touted as the fastest-moving animal on Earth—they can reach speeds of more than one hundred miles an hour when diving—and I had seen video footage of this behavior, but in person it was much more impressive and truly frightening. It seemed unnatural to see an animal moving so fast.

A moment later one of the birds rose back up from below the lip of the cliff and hovered only thirty or forty feet directly above me. Peregrines are well known to dive at people if they feel their nest is threatened, and though it was well past nesting season, I felt a pang of anxiety having just witnessed the terrifying speed of a peregrine's dive. I felt vulnerable so close to the cliff's edge and feared what might happen if several pounds of bird came hurtling toward me at a hun-

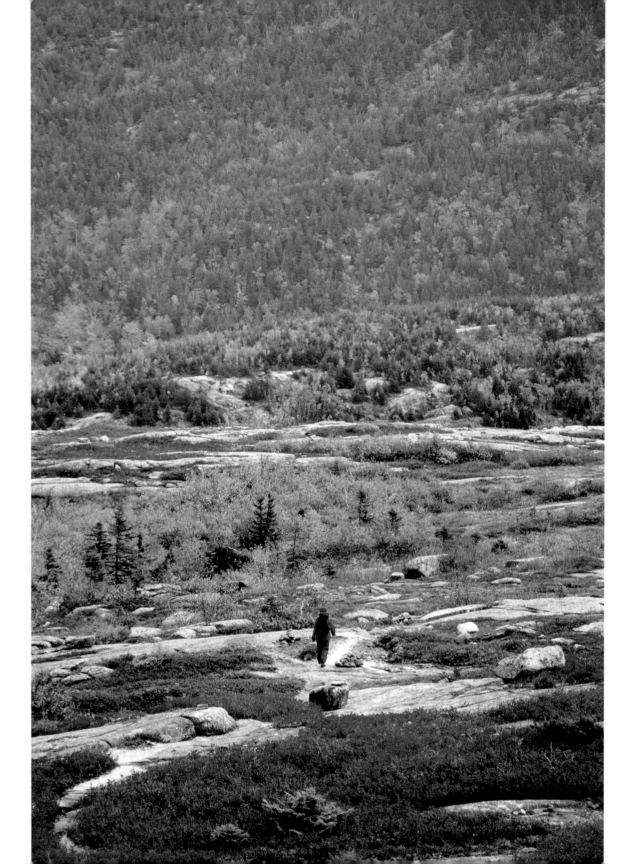

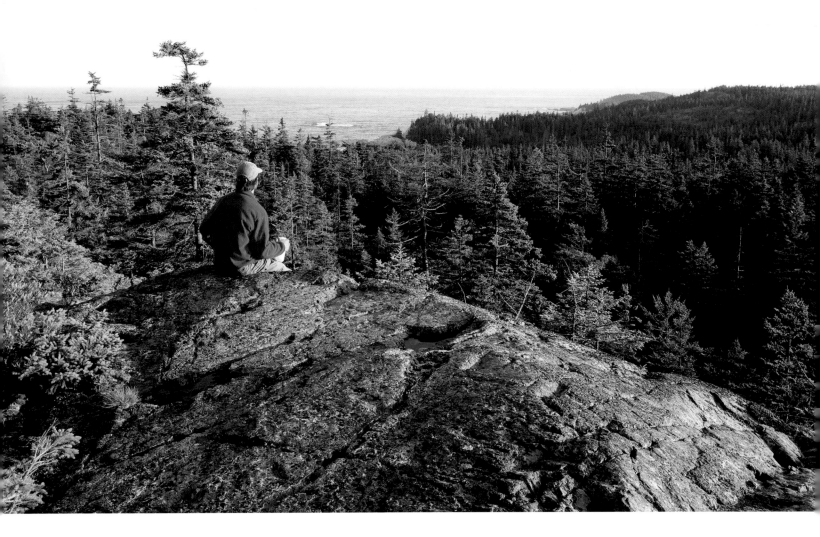

dred miles per hour, talons outstretched like an evilly spiked jousting pole. As the bird tucked for a dive, I did what any courageous nature photographer would do—I ducked under my tripod.

The bird came nowhere near me, bombing down below the cliff's edge and out of sight. It was just like the first dive. After a quick glance around to make sure no one had witnessed my less than daring brush with one of nature's fiercest predators, I let the adrenaline drain from my body and tried to get a look at what the peregrine was hunting for. I couldn't find the bird, and I wouldn't see either of the falcons again that day, but I felt wide awake, very much alive. Despite the threats facing the park, Acadia still obviously has a thriving wild side.

I am not sure what the falcon I saw on Cadillac was doing, although it was probably heading back toward the cliffs on Jordan Pond after a hunting excursion in Frenchman Bay. I took this sighting as my cue to start heading back toward my car, which was a couple of hours away at the base of the North Ridge trail, where I had left it long before sunrise. The sun would be setting in about an hour and the light was beautiful, so I popped off a few more photos of rock and sky before walking back toward the summit. During the two-plus hours I spent away from the summit, I had seen only a couple of other hikers, so I was a little surprised to see the summit still packed with cars and hundreds of people. Now, of course, they were lining up for the westward show—sunset, which was shaping up to be stunning.

I walked past the crowds, camera flashes popping as they had been doing at sunrise, and I made my way to the North Ridge Trail. I was still above tree line when the sun disappeared for the night, and I had a great view to the west of the midnight blue sky clamping down on the horizon's line of orange light. Nearby, a steady stream of red brake lights snaked along the summit road, cars full of happy tourists thinking of lobster dinners and walks with ice cream cones. I turned on my headlamp and hiked down the trail, listening for the quiet I had found here sixteen hours earlier, and looking forward to a night of well-deserved rest. A rest the mountain deserved even more than me.

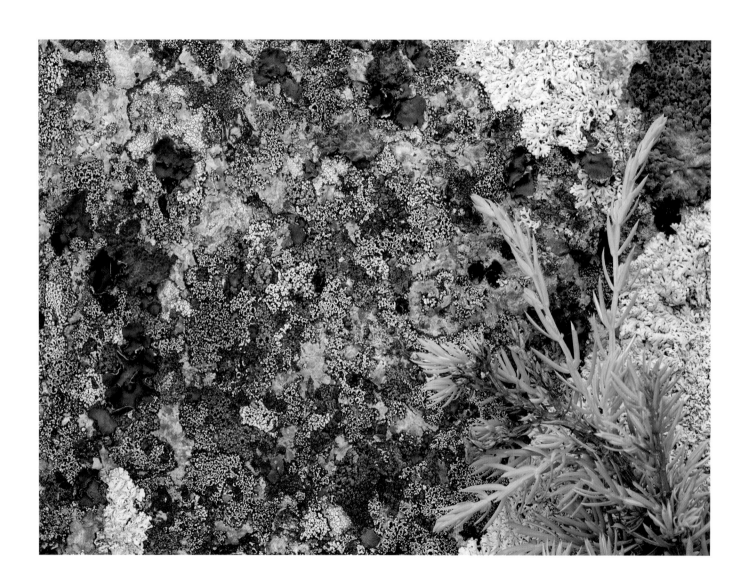

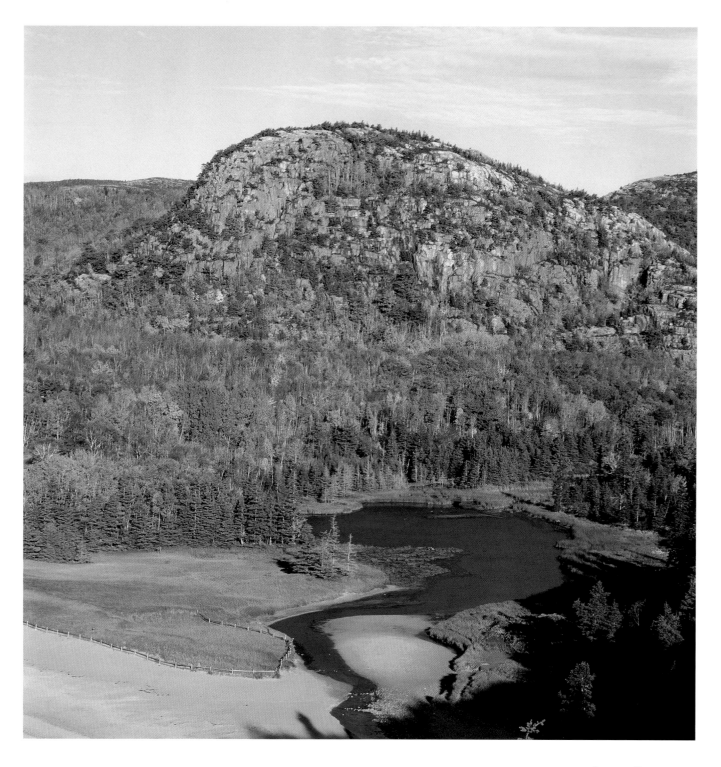

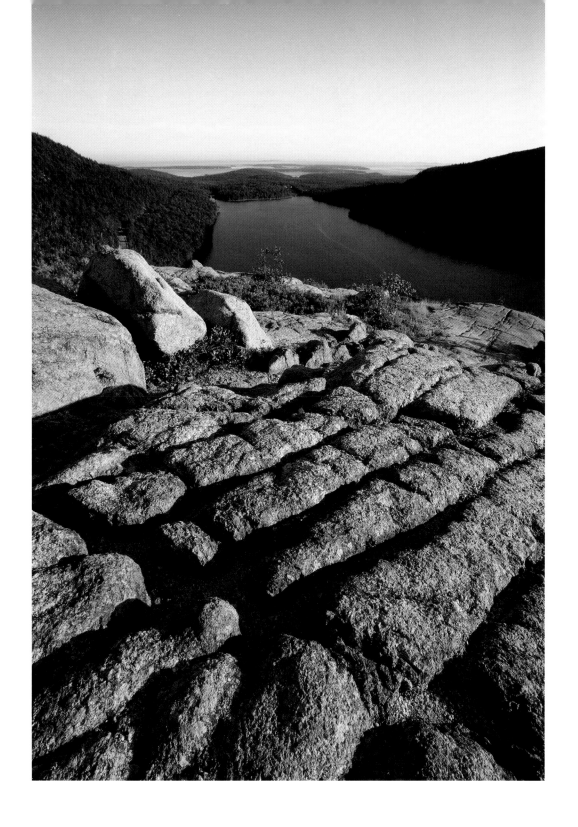

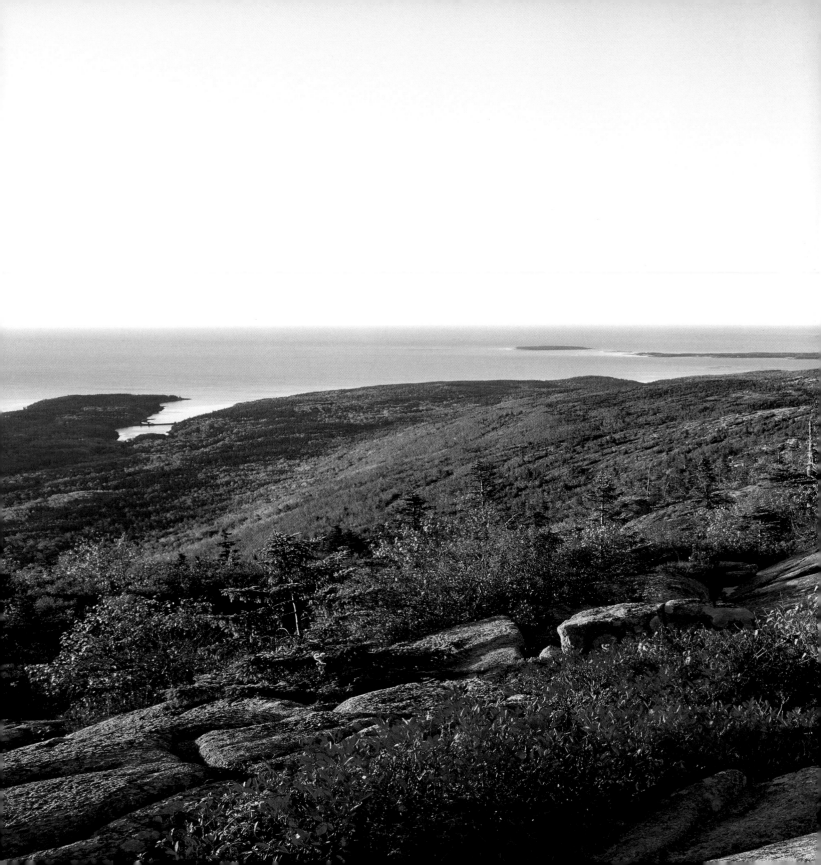

Fall on Cadillac Mountain.

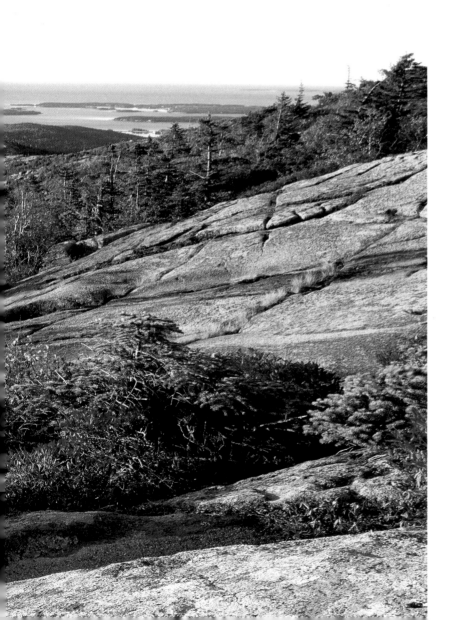

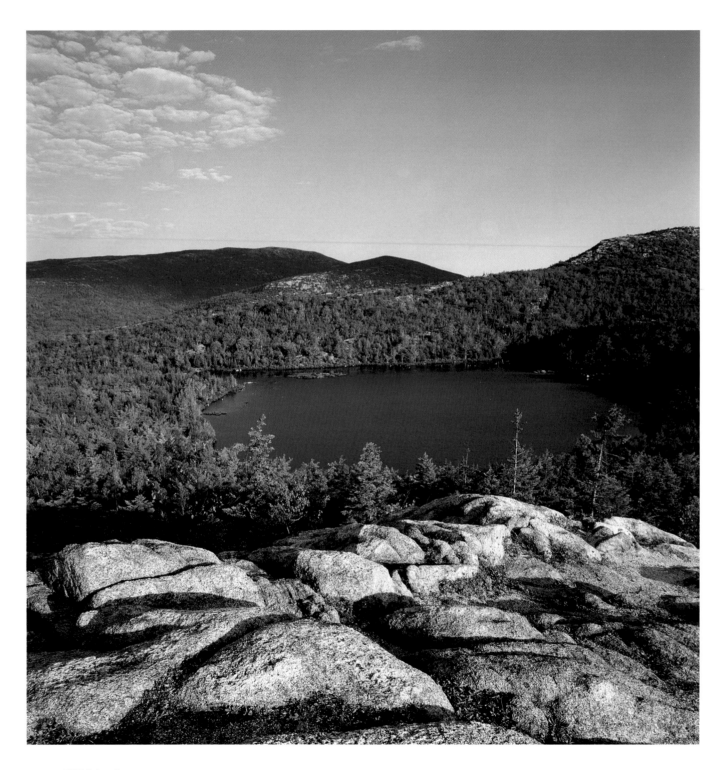

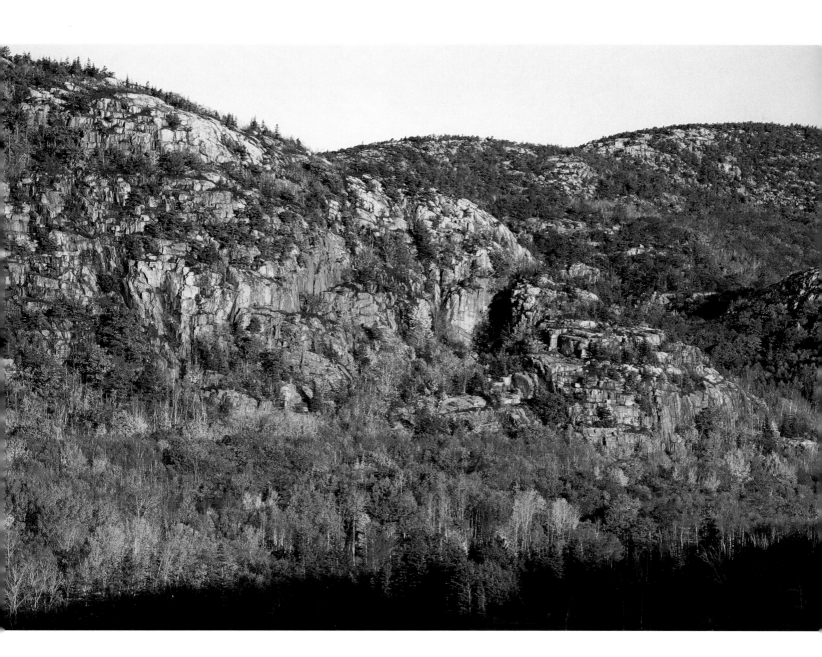

PRESERVING ACADIA

To help preserve the wild character of Acadia National Park, please support the following non-profits.

FRIENDS OF ACADIA | The mission of Friends of Acadia, founded in 1986, is "To preserve and protect the outstanding natural beauty, ecological vitality, and cultural distinctiveness of Acadia National Park and the surrounding communities." In the last decade Friends of Acadia has granted over $5 million to the park and local communities. In its short twenty-year history, it has managed to raise a $5 million endowment to maintain the park's beautiful 44-mile carriage road system in perpetuity and raised $13 million to rehabilitate the 113-mile hiking trail system, making Acadia the only national park in the country to have a fully endowed trail system. Friends of Acadia also spearheaded the creation of the Island Explorer bus system, a free natural-gas-powered public transportation system that significantly reduces traffic on park and local roads, and makes it possible to enjoy many park adventures without the use of a vehicle. To learn more about Friends of Acadia, visit its website at www.friendsofacadia.org.

MAINE COAST HERITAGE TRUST | The Maine Coast Heritage Trust was founded on Mount Desert Island in 1970 specifically to protect land around Acadia National Park and to preserve the integrity of the Acadian archipelago. Since then, it has expanded its focus statewide and has helped to conserve more than 125,000 acres of coastal Maine including more than 250 entire islands. With a satellite office on Mount Desert Island, the Maine Coast Heritage Trust continues to work in the Acadia region, where it has protected more than 13,000 acres, 10,000 of which are now part of Acadia National Park. Some places on Mount Desert Island the Trust has helped to protect include Little Long Pond, Northeast Creek, and Schoolhouse Ledge. To learn more about the Maine Coast Heritage Trust, visit its website at www.mcht.org.

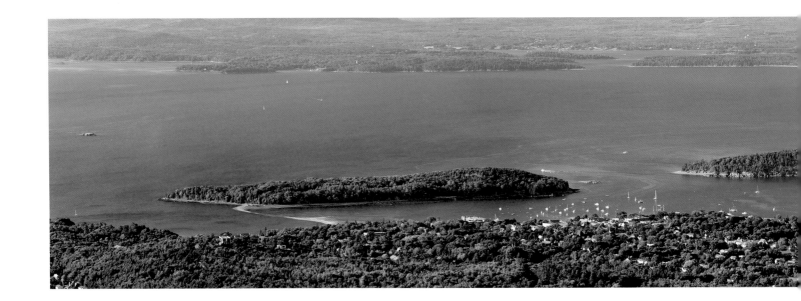

The Porcupine Islands and Bar Harbor.

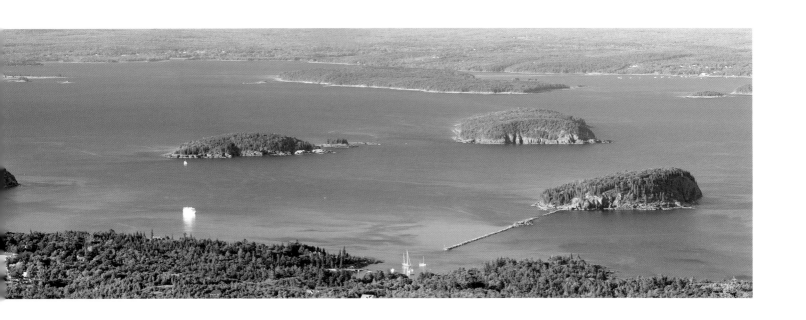